IMAGES
of America

BELLEVUE

AND HISTORIC LYME VILLAGE

IMAGES
of America

BELLEVUE

AND HISTORIC LYME VILLAGE

Bill Drown

ARCADIA

Published by Arcadia Publishing,
an imprint of Tempus Publishing, Inc.
3047 N. Lincoln Ave., Suite 410
Chicago, IL 60657

Printed in Great Britain.

Library of Congress Catalog Card Number: Applied For.

For all general information contact Arcadia Publishing at:
Telephone 843-853-2070
Fax 843-853-0044
E-Mail sales@arcadiapublishing.com

For customer service and orders:
Toll-Free 1-888-313-2665

Visit us on the internet at http://www.arcadiapublishing.com

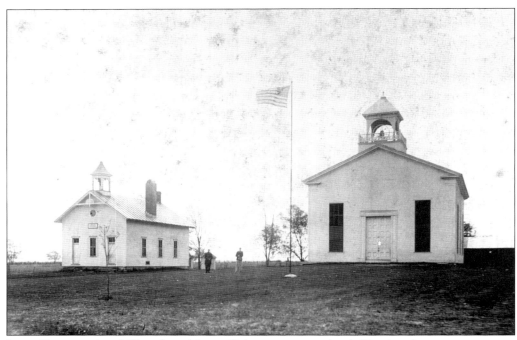

Lyme Congregational Church and Lyme Ridge one room school, District #3.

CONTENTS

ACKNOWLEDGMENTS

I would like to thank the Board of Trustees of Historic Lyme Village for allowing the use of the Historic Lyme Village collection of photos as the basis for this book. I would also like to thank the individuals who were concerned enough about preserving the history of the area that they donated the photos to Historic Lyme Village. I especially want to thank Alvina Schaeffer, volunteer curator of Historic Lyme Village, for preserving these photos practically from the beginning.

I would also like to thank Bill and Ruth Fuehring for sharing their personal collection of railroad photos and preparing the captions for the pictures they provided.

Mr. and Mrs. Richard Bell, owners of Seneca Caverns, freely provided old views of their caverns for use in the book—once again, thank you!

I hope you enjoy this book as much as I have enjoyed putting it together.

Pictured is the entrance to Historic Lyme Village.

INTRODUCTION

Bellevue's first settlers were Mark Hopkins and family, and soon thereafter Elnathan George arrived in about 1815. They constructed log houses on the Huron County side near the Huron/Sandusky County line. Return Burlington soon settled on the Sandusky side and named the community York Crossroads. The town also carried the name of Amsden's Corner after the first shopkeeper, Mr. Thomas G. Amsden. His shop was located near the present-day intersection of Exchange and Main Streets.

At the same time small villages were popping up in the surrounding areas: Lyme, Hunts Corners, North Monroeville, Monroeville, Clyde, Parkertown, Castalia, Vickery, Clyde, Mt. Pleasant, Mt. Carmel, Colby, Fireside, Flat Rock, Franks, Weavers Corners, and many others. Most of them had post offices, churches, stores, blacksmiths, and depots if trains passed through them; many of these only exist as crossroads today.

Most of the area was rural farmland, but it was not isolated because of the main roads leading into and out of the area. These included State Route 18 (Kilbourne Road), State Route 113 (Strong's Ridge), and West Road (now know as North West and South West Road because it was the western boundary line of the Connecticut Western Reserve and the Firelands). State Route 4 was originally a corduroy road in our area and, along with US 20, was a toll road.

The mid-1800s brought railroads that provided growth to the towns that they passed through, and eventually brought an end to those that were passed by. The latter part of the 19th century brought the interurban Lake Shore Electric.

Bellevue celebrated a centennial of its settlement in 1915. Another celebration was held in 1953, the centennial of it becoming a city. The celebration was delayed while the Main Street was being replaced; it was so bad that *Life Magazine* carried an article calling it the worst Main Street in America.

The year 1976 saw a resurgence of appreciation for American history as the United States celebrated its Bicentennial. The Mad River NKP Railroad museum began in 1976 and Historic Lyme Village began in 1977. They quickly became popular tourist attractions joining Seneca Caverns, which had been established in the first part of the 20th century.

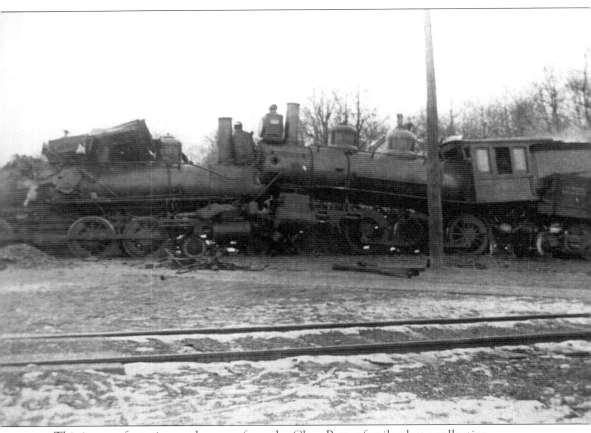

This image of a train wreck comes from the Clara Potter family photo collection.

One
HISTORIC LYME VILLAGE

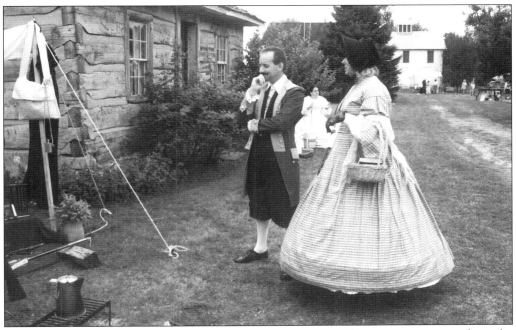

Pioneer Days at Historic Lyme Village is a very popular special event. Re-enactors from the local area, as well as from around the country, come to participate.

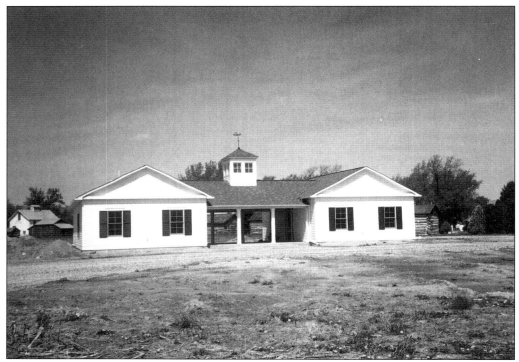

This is Historic Lyme Village's Visitor's Center, which was constructed in 1998. The Visitor's Center added much needed public restrooms, a research library, gift shop, and business office to the Village. The Biebricher Barn is visible in the rear left of this picture.

Historic Lyme Village is seen from the center court of the Visitor's Center.

The Memorial Rock is located by the flagpole in front of the Lyme Post Office. This commemorates the gift of the original lease of land that allowed the establishment of Historic Lyme Village. Doctors Ross and Ian Irons gave leases for the land in memory of their mother, Doris Irons. Cheryl Irons and Dr. Bauer eventually donated these two parcels of land. The paving bricks came from the old US 20 roadbed in York Township.

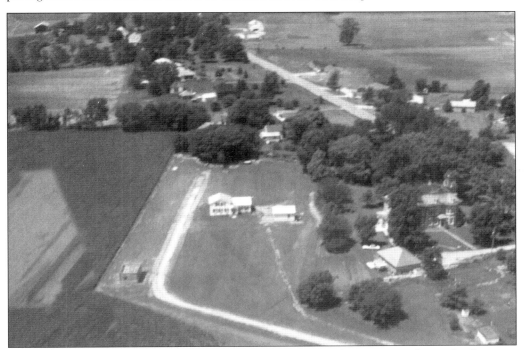

An airplane view of the grounds of Historic Lyme Village, taken in 1977, shows the Seymour House located in center of photo. The Annie Brown Log Home is on the left at the curve of the Driveway. The Wright Mansion is in the trees to the right, and State Route 113 is in the background.

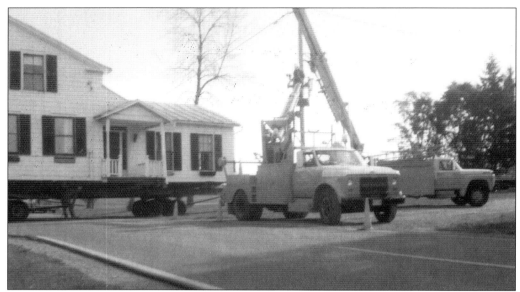

The Seymour House became the first building to be relocated to Historic Lyme Village. This picture shows it on wheels being pulled across State Route 113. The truck on the right is located on Lyme Church Drive. The Seymour House was donated to the Historical Society and would have been destroyed if the society hadn't relocated it in 1975. The Historic Lyme Church Association led a "Save the Seymour House campaign."

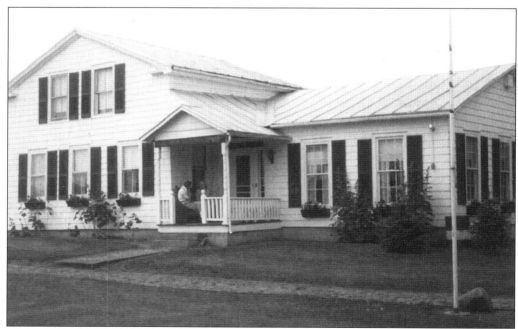

Here, the Seymour House is pictured on site at Historic Lyme Village after restoration. It was originally built in 1836, across the road from the Lyme Church. This photo was taken in 1986 at its 150th anniversary. It serves as a museum with some restored rooms and many displays of historic artifacts.

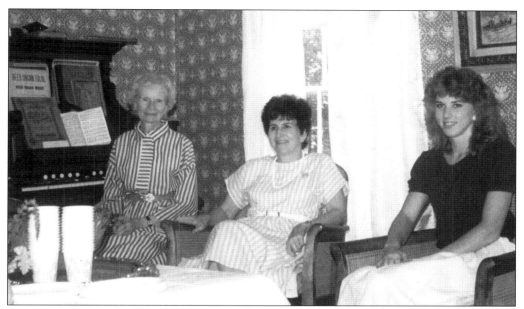

The Parlor in Seymour House set up to celebrate the 150th anniversary. Pictured, from left to right, are long time guides Mary Leininger, Betty Seymour (widow of Robert Seymour, Board Member and volunteer), and Bobbi Seymour (6th generation descendant of the Seymour that built the house).

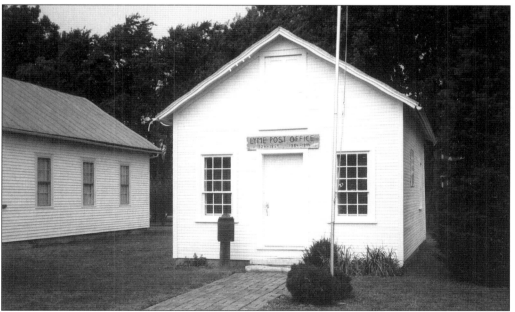

This building housed the Lyme Post Office from 1884 to 1894. Most likely, it housed a general store with the post office in one corner. It also housed the Postmark Collector's Club Museum after being restored at Lyme Village, until they moved their extensive collection to the Groton Township Hall. The building now houses displays related to the Lyme Post Office and its history.

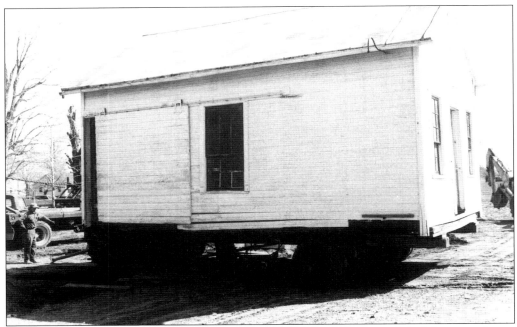

The Lyme Post Office building stood behind the Seymour House and had been used as a carriage storage building for many years. The society received it when they were given the Seymour House. This is a photo of it being moved to the Village location on wheels in 1976.

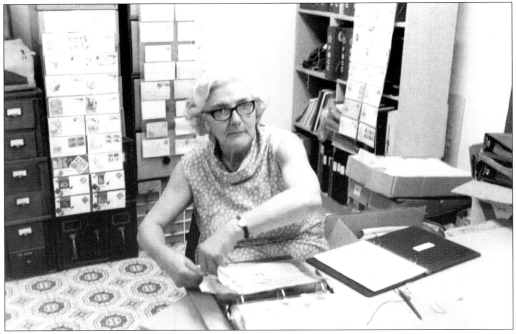

Bernice Mittower was instrumental in locating the Postmark Collector's Club at Historic Lyme Village. She served as curator of their collection for many years.

This view of the Post Office shows the building under restoration. Richard Hammel led the efforts. Will Cook, founder of Lyme Village, and Alvina Schaeffer, who became long time curator of Lyme Village, pose in front of the project in 1977.

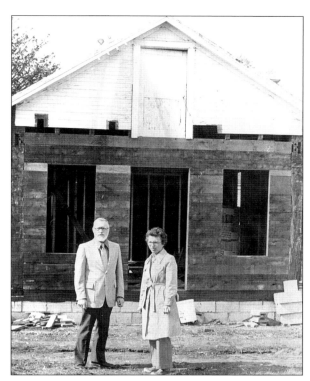

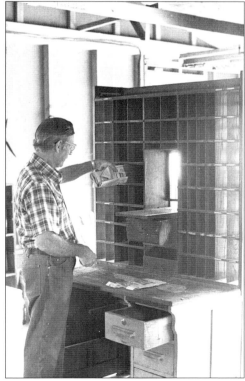

Melvin Herner, one of the original Historic Lyme Village volunteers, demonstrates how the mail would have been sorted in the old post office boxes in this 1976 photo. The post office boxes are from the Kimball Post Office.

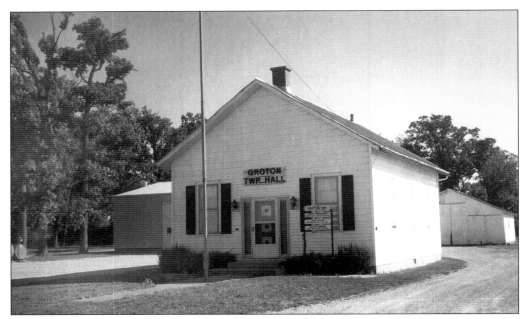

The Groton Township Hall building is seen as it looked at its original location on Strecker Road. This building was offered to Lyme Village when the Parkertown quarry was expanding. The Postmark Collector's Club moved it to our Village to house their expanding collection.

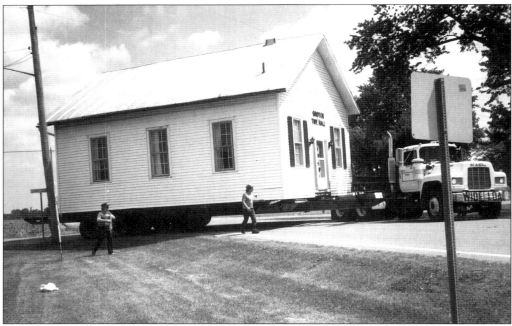

Groton Township Hall building is on wheels coming around the corner at Strecker Road and State Route 4, on it's way to Historic Lyme Village in 1993. The building now houses the Postmark Collector's Club's national museum. The world's largest collections of postmarks are housed in this building.

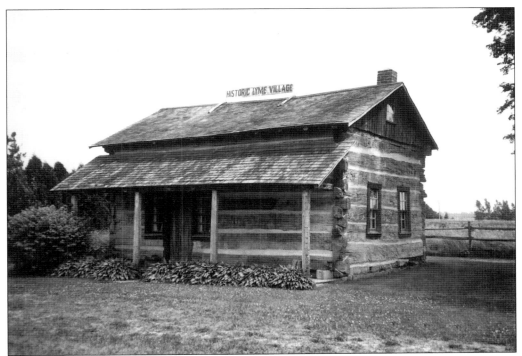

Annie Brown Log Home is pictured as it looked after restoration in 1998, before the new visitor's center was built and additional land was added to the south of the Village.

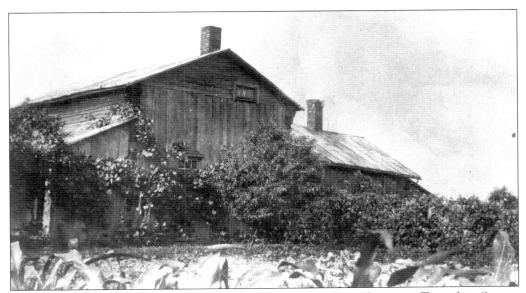

Annie Brown Log Home is seen as it looked on its original site in Thompson Township, Seneca County. The house was built in 1851 and was lived in until 1951. Alloys Brown donated the building to the Historic Lyme Village. It was dedicated in 1978 in its restored condition.

In this photo, the Annie Brown Log Home is under restoration, and the Seymour House, Lyme Post Office, and the back of the John Wright Mansion can be seen.

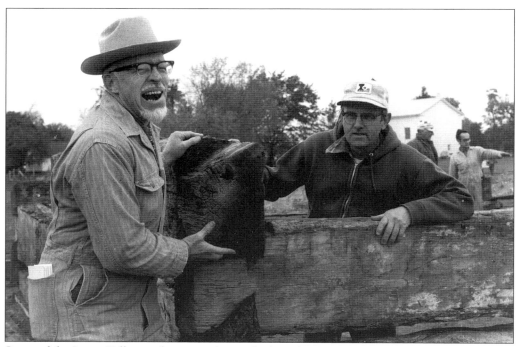

Some of the Lyme Village volunteers who worked on the Annie Brown Log House Restoration are pictured here. Seen from left to right are Will Cook, Willis Lodge (in charge of restoration), unknown, and Bill Weber. Historic Lyme Church is in the background.

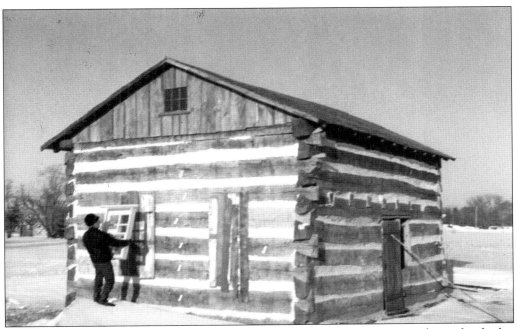

Mel Herner is checking new windows for the Annie Brown Log House—it's almost finished.

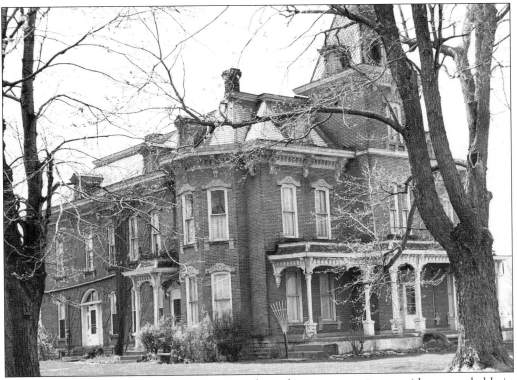

This is a photo of the John Wright Mansion taken when it was a private residence, probably in the early 1970s.

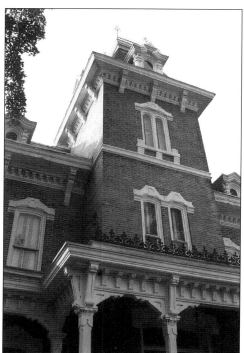

Here is a close-up showing the tower of the John Wright Mansion. The Historic Lyme Village purchased the mansion in 1979. It added much-needed museum display area and land to the Village as well as our own entrance driveway; previously, we entered through the Historic Lyme Church property.

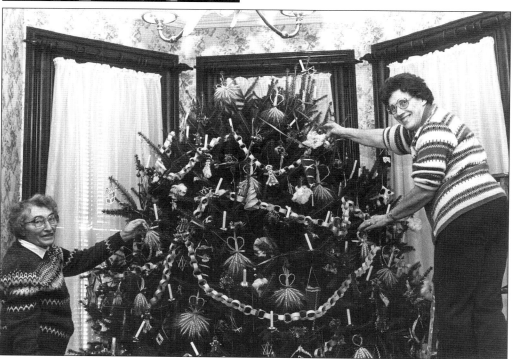

This photo shows two of our Village volunteers decorating the John Wright Mansion for Christmas of Yesteryear in 1979. The volunteers are Dorthea Crecelius (left) and Ruth Stoltz (right).

John Wright Mansion front entrance hall and newel post on main stairs. The carpet in the picture was installed in the 1930s, when the house was converted to a tea room catering private parties.

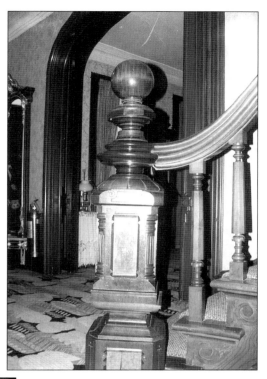

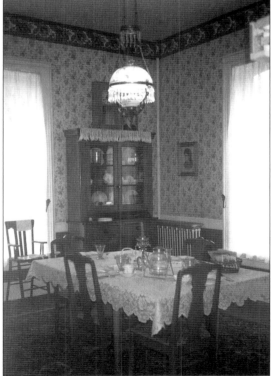

Pictured is the recently restored informal dining room in the John Wright Mansion. Dennis Bauer led restoration work in 2001. One of the heating steam radiators is visible—these were installed in the mansion when it was constructed in 1882 and are still in use.

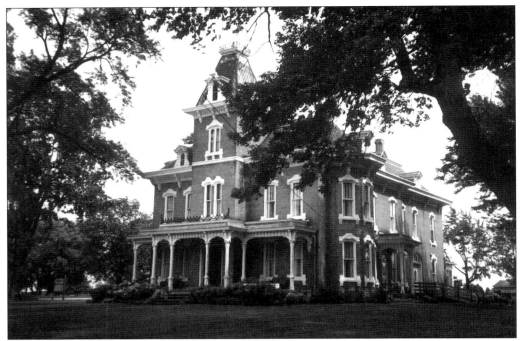

The John Wright Mansion was built by John Wright and his family in 1882. The family made the bricks in kilns constructed on the property, and the lumber was produced in sawmills also located on the property. It is the centerpiece of the present day Historic Lyme Village.

The Shriner Weidinger Log Home is seen at its original location in Reed Township, Seneca County. The house was constructed in 1851 and stood about a mile from the original location of the Annie Brown Log Home.

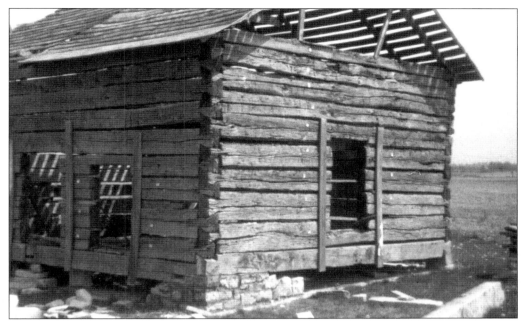

Above, the Shriner Weavers Log Home is pictured while being restored at Historic Lyme Village in 1981. Some of the stones used in the foundation were originally from the Old Stone Church located near Flat Rock, Ohio.

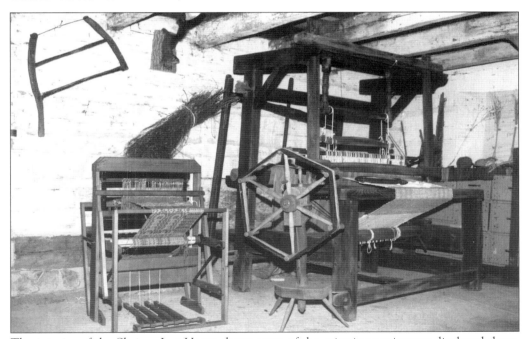

The interior of the Shriner Log Home shows some of the spinning equipment displayed there. The large loom is from the Leedy (Seybert Museum) and dates from the very early 1800s. The small loom was donated by Charlotte Dillon in the 1970s. Charlotte was the driving force behind making the log house into a spinner's display cabin.

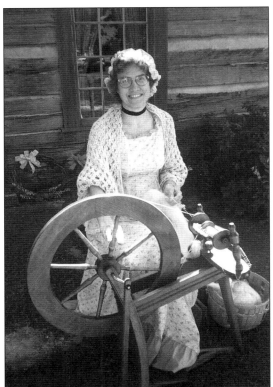

This photo shows Janice Jordan demonstrating the art of spinning wool in front of the Shriner Log Home. She is one of Lyme Village's long time volunteers.

The Wagner Log Home is seen at its original location west of Fremont, Ohio, on US Route 20. A small portion of siding has been removed, exposing logs. The house was originally constructed around 1830 as the Rose Tavern. The home was a full two stories; it had two rooms up and two rooms down. Log walls divided the rooms. The upstairs had an exit door from each room in the back.

The Wagner Log Home is pictured at its original location with roof being removed and all of the logs exposed.

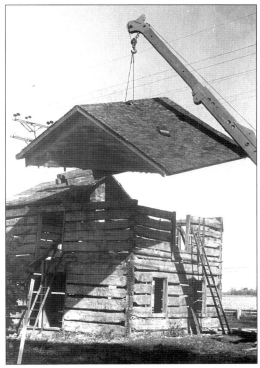

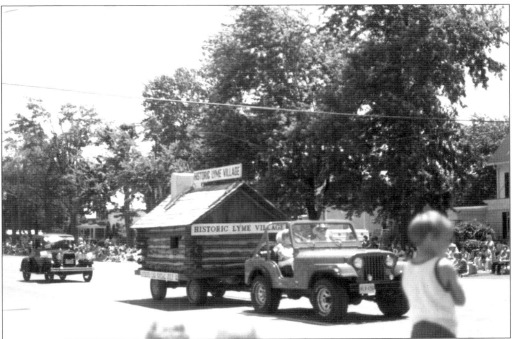

Historic Lyme Village constructed a log house on a wagon that was used in parades for many years. It is pictured here in the Cherry Festival Parade in 1981. When it wasn't being used in a parade, it was parked in the front yard of the Wright Mansion as the Lyme Village sign.

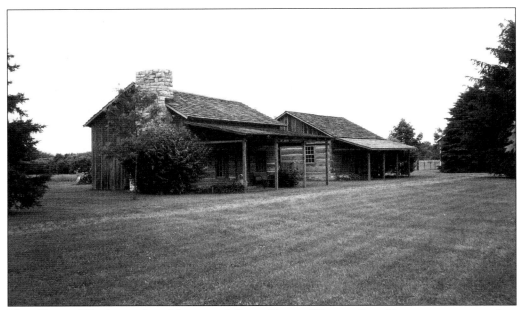

The Shriner/Weidinger Log Home and Rose Tavern/Wagner Log Home were restored at Historic Lyme Village. Porches were added to the front to help preserve the exposed logs on the fronts of the homes. The Shriner Home also had board and batten siding placed on the ends for the same purpose.

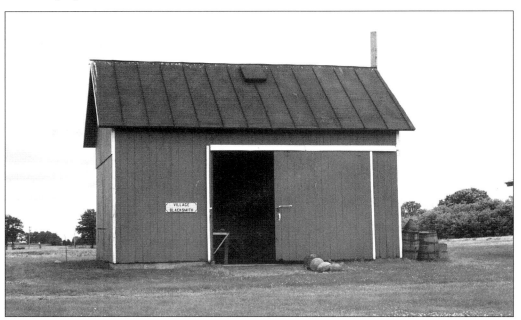

The Blacksmith Shop at Historic Lyme Village originally stood on Potter Road on the North Adams farm, north of Bellevue. It was originally used as a granary. Village volunteers moved the building to the Village and removed the grain bins. John Schaeffer led the group. The rocks displayed in the picture are concretions, a natural round rock formation found in the area between Lyme and the Huron River.

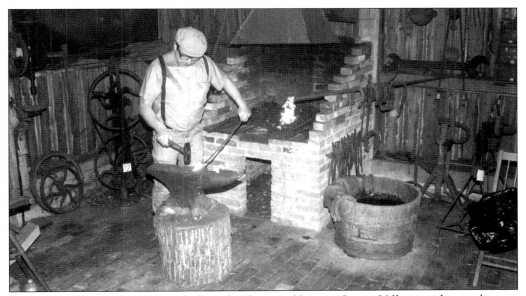

The restored interior of the Blacksmith Shop at Historic Lyme Village with a volunteer demonstrating the art of Blacksmithing; much of the equipment was donated by Wilma McVetta from her father's blacksmith shop in Castalia, Ohio. Her father's name was Mr. Green. The large grinding wheel found in the Blacksmith Shop was used in smoothing the strap rails for the original construction of the Mad River Railroad.

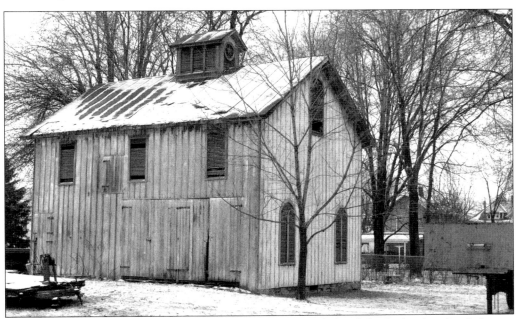

The Biebricher Barn originally stood on West Main Street behind the Biebricher family home. The home was converted to a nursing home by the Bellevue Hospital, and served for many years. When it was going to be torn down to make way for a Wendy's Restaurant, the Hospital donated the barn to Historic Lyme Village. The Village hired an Amish crew to dismantle the barn and re-erect it in the Village. This is what it looked like before the move.

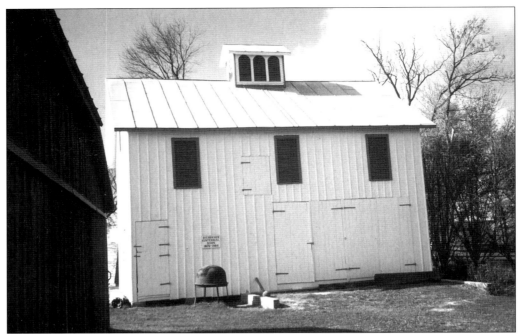

The Biebricher Barn is seen at its restored location at Historic Lyme Village. The barn was originally constructed in the 1870s and is considered a Centennial Barn because of the star ornament located on the louvers in the cupola.

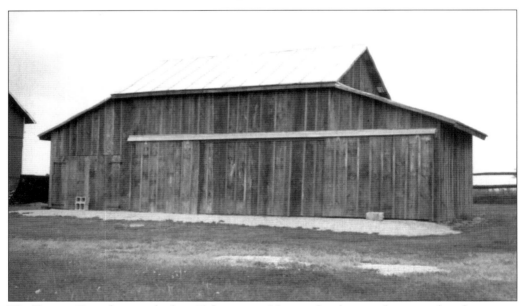

The Kromer Barn dates to the late 19th century. Not much is known about it, other than it was owned by the Carl Kromer family for many years and was located on his farm on Campbell Street in Perkins Township, south of Sandusky. A crew led by John Schaeffer and Denver Weiland dismantled the barn. A crew led by Edgar Shelly as well as some Amish put the building back up. The picture shows the restored building as it looks in the Village.

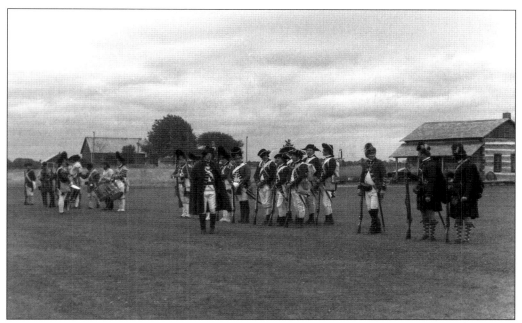

The Revolutionary War re-enactors were at one of Lyme Village's War Days celebrations in the late 1970s. The Annie Brown Log Home is seen in the background.

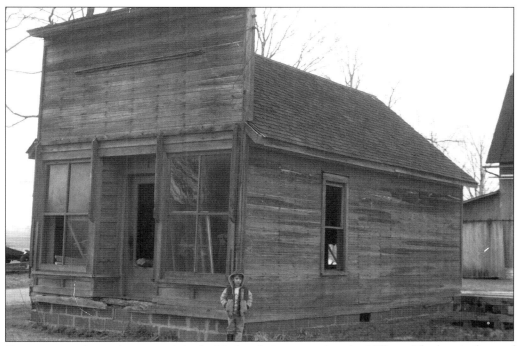

Cooper general store is seen as it looked before being moved to the Village. The boy in front of the building is Andrew Drown, son of the author. This building was originally a gas station, store, and motorcycle shop. Tom Fries gave it to the Village. It originally stood on State Route 18 in Cooper, Ohio, south of Bellevue in Seneca County.

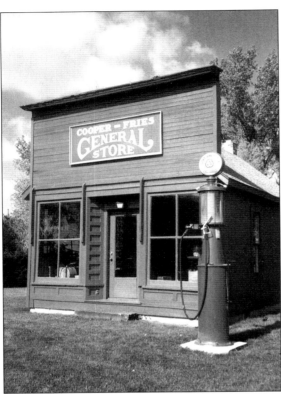

Cooper Fries General Store is pictured in its restored state in the Village in 1997.

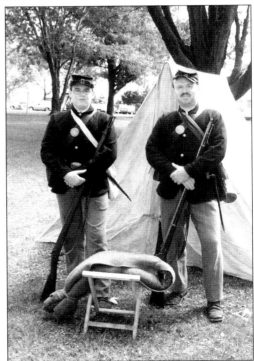

Civil War re-enactors Matt Burr and son pose for a picture during a Pioneer Days event at Historic Lyme Village.

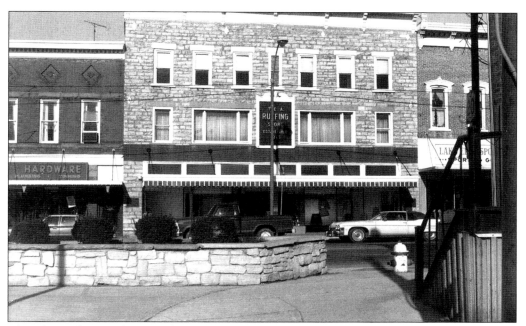

This photo shows Schug Hardware on the left as located in downtown Bellevue, Ohio. The large stone building was for many years the A. Ruffing Clothing Store. Schug Hardware was located on one side of this building before it moved to the location next door.

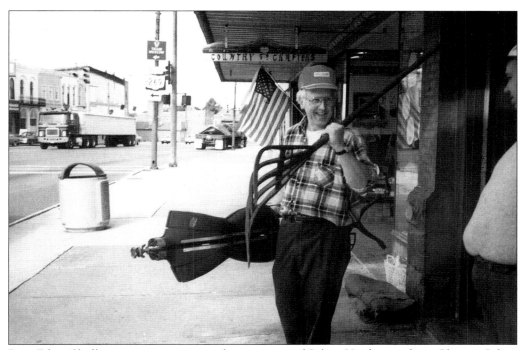

Rev. Edgar Shelly is carrying items out from upstairs of Schug Hardware where Clayton Schug had stored them for many years as he planned for a Schug Hardware Museum. Bill Drown watches on.

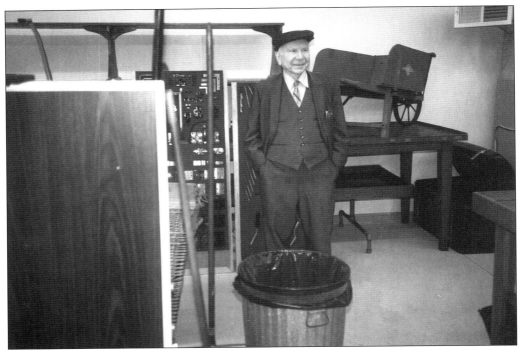

Clayton Schug checks out the new Schug Hardware Museum constructed at Historic Lyme Village. Clayton contributed the money for the construction as well as planning the building and placing of the items after they were located there.

The Schug Hardware Museum at Historic Lyme Village was dedicated on June 23, 1996.

The Village Woodworking Shop is also located in Lyme Village. Originally a summer kitchen located at the Biebricher House, it was moved to Lyme Village by volunteers. This photo was taken in July of 2000.

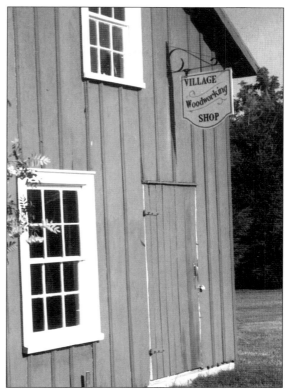

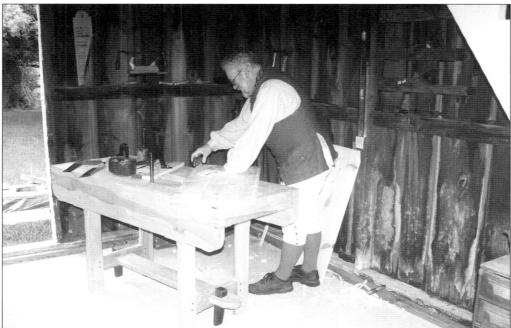

This photo shows Lyme Village woodworker Jack Montgomery hard at work inside the Village Woodworking Shop.

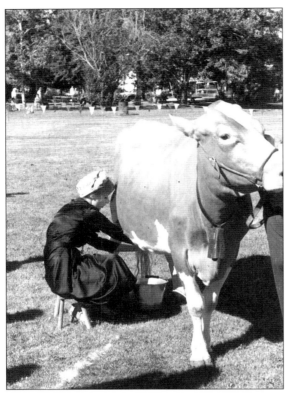

Board member Kathy Segna re-enacts (1979) the famous cow milking on Park Avenue in New York City (1929) by Thompson Township resident Jessie Bastain. The Ohio Society in New York City declared the Heter Cowbell the "Oldest Cowbell in Ohio." They conducted an extensive search and selected this cowbell as the oldest. They used the cowbell to call their meetings to order. When the society disbanded in the 1970s, they selected the Historic Lyme Village as the permanent home for the cowbell.

Goats and chickens were added to the Village Farm in 2002.

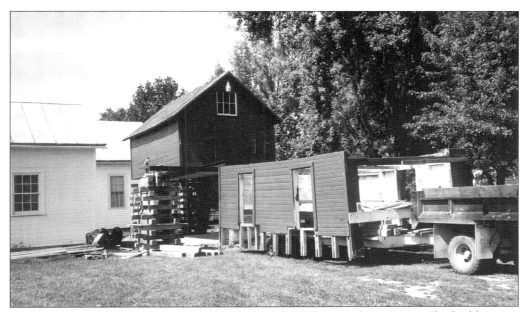

Professional movers brought the Foos building to the Village in three pieces. The building was originally an out building at the Greenslade home on West Main Street and Greenwood Heights in Bellevue. The Postmark Collector's Club assisted with the cost of the move in order to use a portion of the building for much needed storage.

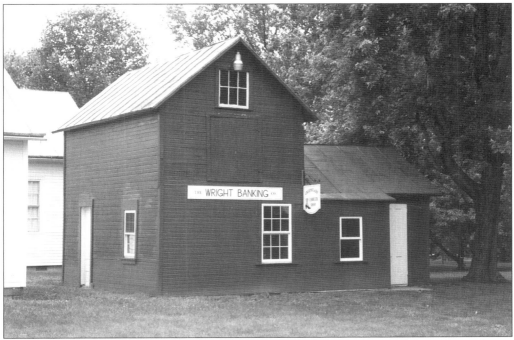

The restored Foos building now houses the Greenslade Cobbler's Shop, with displays relating to the shoe business. The inside of the building is lined with old wood from shoe crates that were placed there by Mr. Greenslade. We also have a Wright Bank exhibit inside the window.

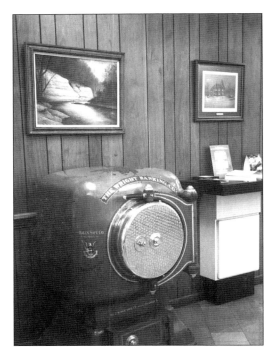

At left is Wright Banking Co. safe as it looked inside the former Wright Banking building, now Croghan Colonial Bank at Union Square in Bellevue. The safe is now on display in the Wright Bank exhibit. Notice in the photo the painting to the right is a Jim Andrews print of his John Wright Mansion painting.

To the right, this picture shows some of the exhibits inside the Greenslade Cobbler's Shop. The wall is made up of old wood from shoe crates nailed there by Mr. Greenslade.

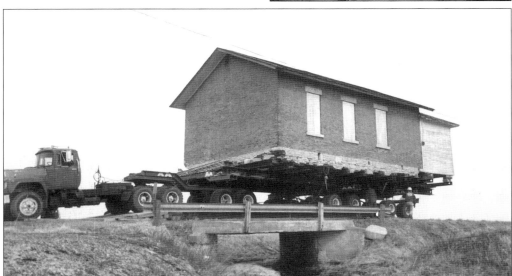

The Merry School House originally stood on Thomas Road in Groton Township, Erie County, Ohio. AAA Movers from Euclid, Ohio were hired to move the building to Historic Lyme Village. This photo shows it crossing a bridge on Strecker Road. This was quite a sight to see.

This is a photo showing the restored Merry School House at Lyme Village. The one room school was originally built in the 1840s. The Detterman Log Church is on the right.

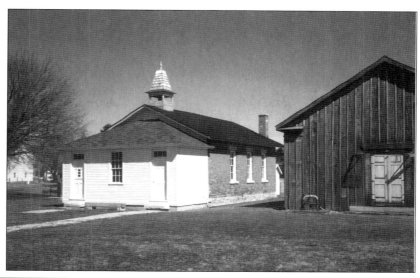

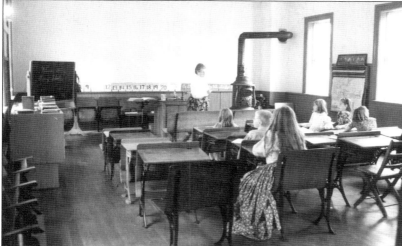

Shirley Waldock is leading the schoolchildren inside the restored Merry School during one of our special events in 1996.

This photo from the Leedy Collection, taken in the 1920s, shows the Detterman Log Church as it stood behind the Detterman House on Adams Township Road 138, just west of State Route 19 in Seneca County. The building was being used as a farm building at the time.

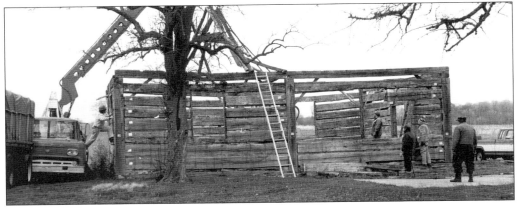

Here, the Detterman Log Church is being prepared to be moved to Lyme Village, the logs are numbered. Eben Root is the man on the left with the crane. The building is extremely rare, as it is only one of a few original log church buildings that remain in Ohio. The type of log architecture is even more rare mortise tendon.

This photo shows the discovery of the unusual mortise tendon construction that was revealed when the siding board was removed. Ola Mae Detterman gave the building to the United Methodist Church in 1992. The Bishop Seybert Museum oversaw the dismantling and restoration of the building. The Historic Lyme Village Board allowed the Seybert Museum to place the building at Lyme Village while Seybert retains ownership of the building. The author's son Andrew Drown is in the photo.

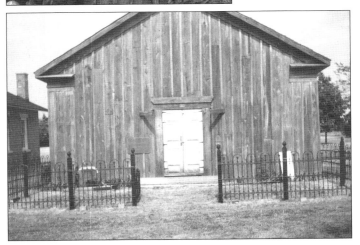

An iron fence sits in place in front of the Detterman Church building. The church is part of the Bishop John Seybert/Flat Rock Cluster United Methodist Heritage Landmark.

The General Conference of the United Methodist Church bestowed this designation in 1992. The building was constructed in 1848 and was used as a church until 1875.

Two

GLIMPSES OF
BELLEVUE, OHIO

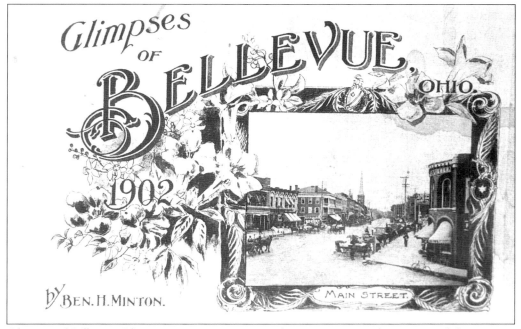

Glimpses of Bellevue, Ohio was written in 1902, and gives a very good overview of the town as it was at the beginning of the 20th century.

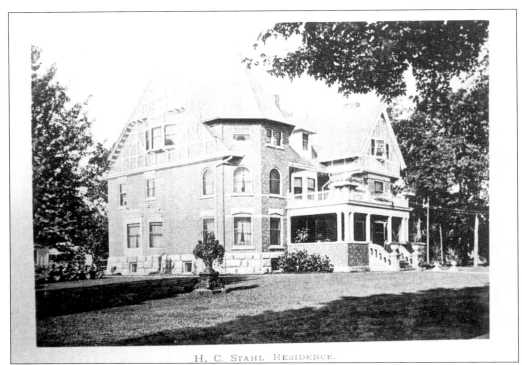

H. C. STAHL RESIDENCE.

H.C. Stahl was a local industrialist who owned and operated the Ohio Cultivator Company. His home is located on West Main Street.

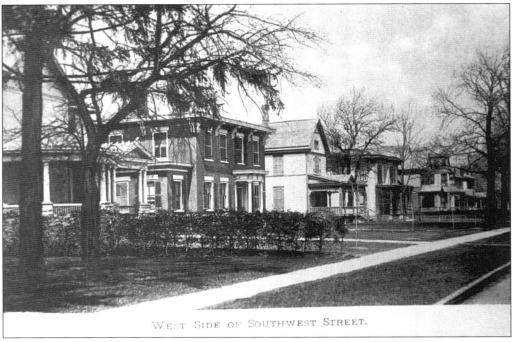

WEST SIDE OF SOUTHWEST STREET.

This photo shows a view of the homes and businesses on the west side of Southwest Street.

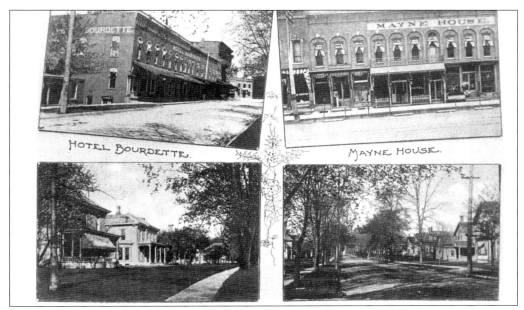

The Hotel Bourdette was located on Kilbourne Street where the CVS Drug Store is now located. The small building on the roof covered a stained glass dome that was in the hotel. The Mayne House was located on the north side of Main Street. The two houses in the bottom right photo are still standing on West Main Street, although one now has tall pillars on the front.

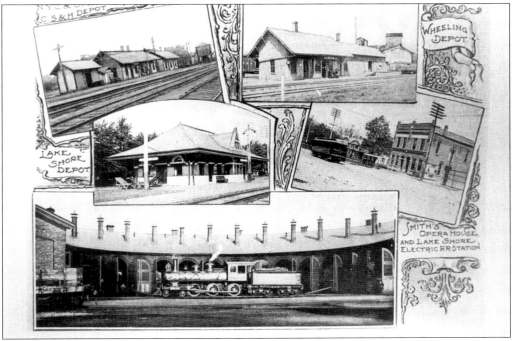

This photo shows Bellevue's railroad related buildings: NYC & St. Louis and C.S. & H. Depot; Wheeling Depot; Lake Shore Depot; Smith's Opera House; and Lake Shore Electric Railroad Station. The front picture shows the roundhouse of the NYC & St. Louis Railroad.

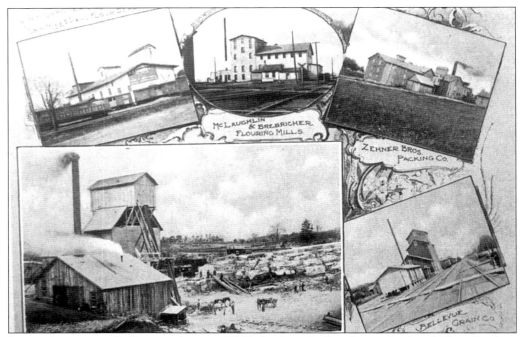

Pictured are major Bellevue industries: W.H Gardner & Co. Grain, Seed and Flour Dealers; McLaughlin & Biebricher Flouring Mills; Zehner Bros. Packing Co.; Bellevue Stone Co.; and Bellevue Grain Co.

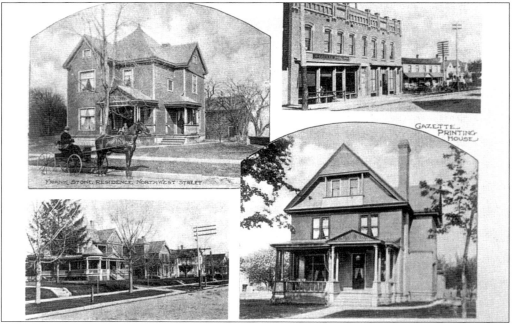

Some prominent Bellevue homes are pictured above: Frank Stone residence on Northwest Street; Gazette Printing House; Northwest Street residences; F. Wolfrom residence; and homes on Northwest Street.

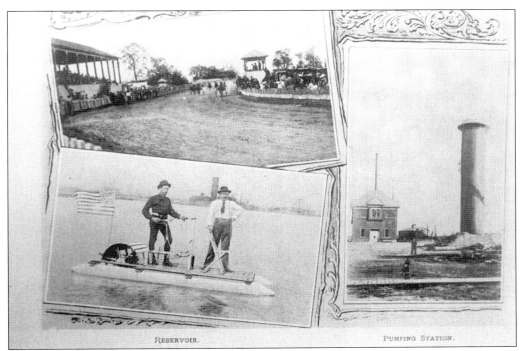

RESERVOIR. PUMPING STATION.

The Bellevue Driving Club, Reservoir, and Pumping Station are in this early photo.

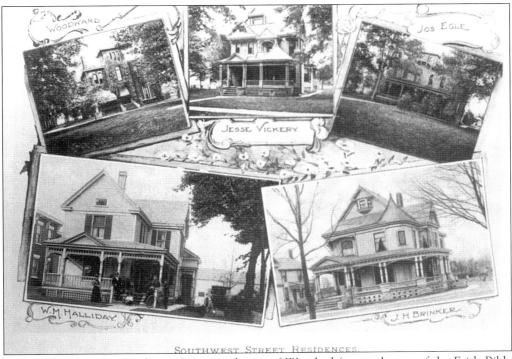

SOUTHWEST STREET RESIDENCES.

Featured here are the Southwest Street residences of Woodard (presently part of the Faith Bible Church), Jesse Vickery, Jos Egle (present Bellevue Fire Station), W.M Halliday, and J.H. Brinker.

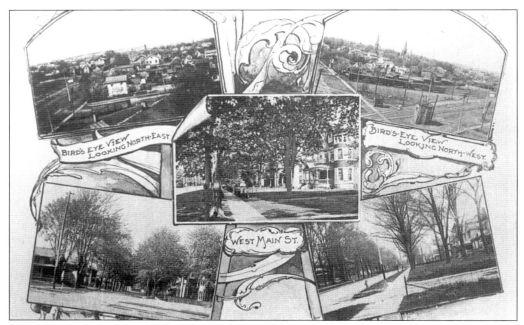

Several views here show off the beauty of turn-of-the-century Bellevue: birds-eye view looking northeast; birds-eye view looking northwest; West Main Street; York Street; Southwest Street looking south.

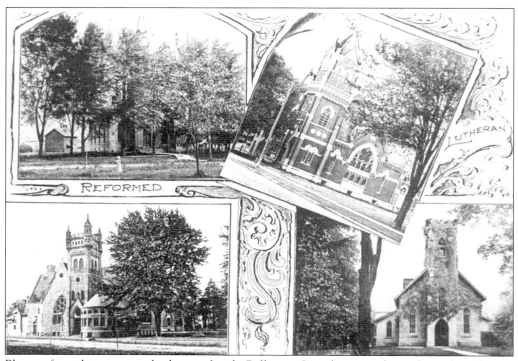

Places of worship were at the heart of early Bellevue. Seen here are the Reformed, Lutheran, Congregational, and Episcopal Churches.

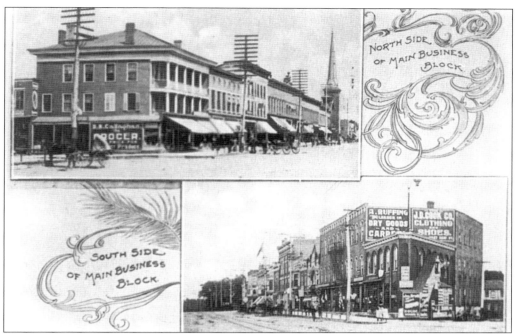

Pictured here are the north side and the south side of Main Street's business block, downtown Bellevue.

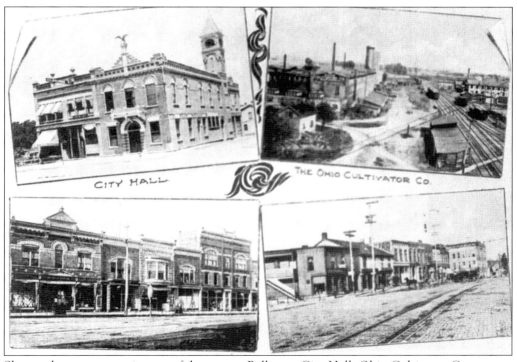

Shown above are more images of downtown Bellevue: City Hall; Ohio Cultivator Co.; corner of Sandusky and Main Streets; corner of Southwest and Main Streets.

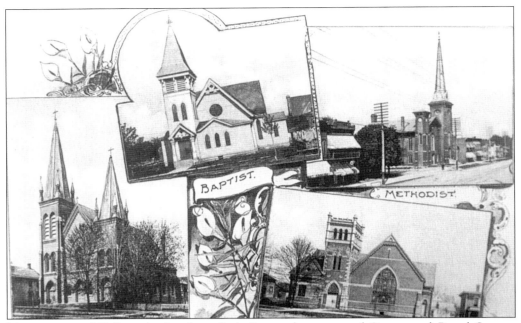

More images of Bellevue's churches: Catholic, at the corner of Center and Broad Streets; Baptist, on Lyme Street near Main Street; Methodist, at the corner of Sandusky and Main Streets; Evangelical on East Main Street near the railroad.

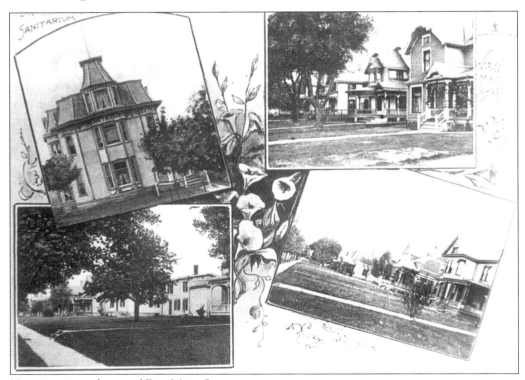

Here is a nice of view of East Main Street

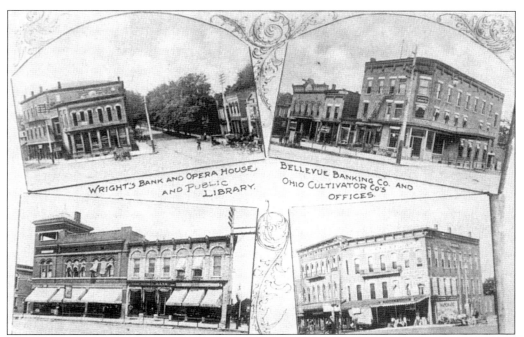

More downtown scenes: Wright's Bank, Opera House, and Public Library; Bellevue Banking Co. and Ohio Cultivator Co. offices; First National Bank; Corner of Main and Kilbourne Streets.

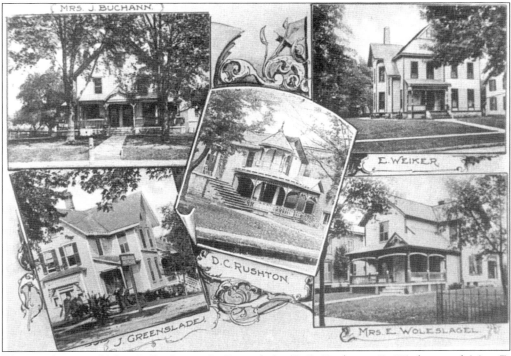

The residences of Mrs. J. Buchann, J. Greenslade, D.C. Rushton, E. Weiker, and Mrs. E. Woleslagel are seen here.

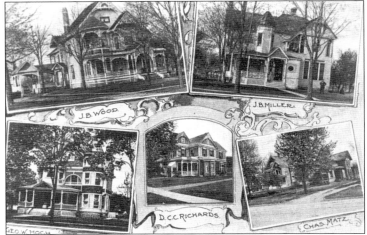

West Main Street residences pictured at left include the homes of J.B. Wood, J.B. Miller, G.W. Hoch, D.C.C. Richards, and Chas Matz.

Education was at the core of early Bellevue, and seen here are the McKim Street School, Central High School, and West Main Street School.

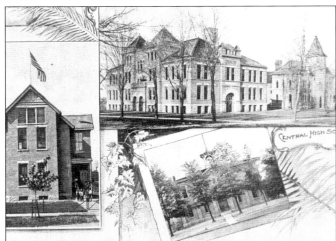

Pictured below is the Orphan Home in Flat Rock, Ohio.

Three
BELLEVUE BUSINESSES AND HOMES

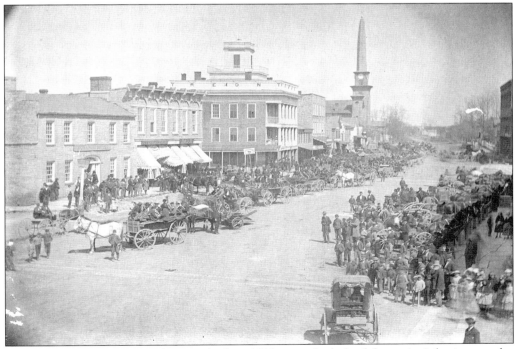

Bellevue's Main Street, seen here in the late 1800s, was the hub of the region's business and social activity.

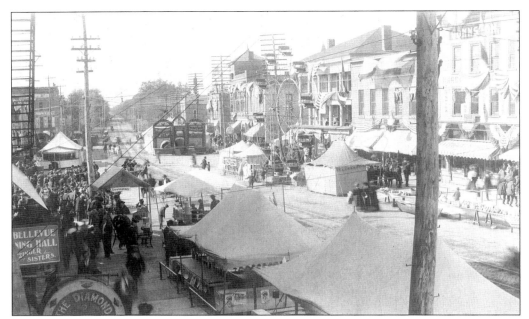

This photo shows a street fair held in Bellevue, Ohio on October 19, 1906. Johnson Hardware is located on the right and was the forerunner to Schug Hardware.

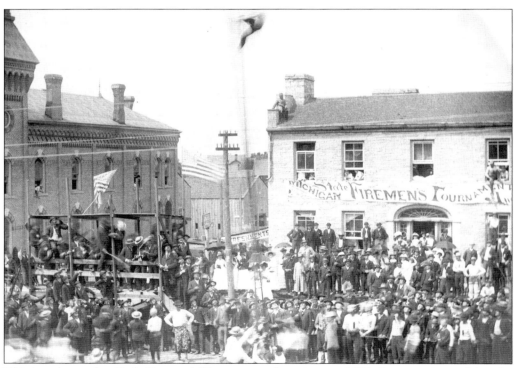

This is a photo of an Early Firemen's Tournament from August, 1884. Everyone is watching the man climbing the ladder in the middle of the photo. The buildings are located on the corner of Main and Exchange Streets.

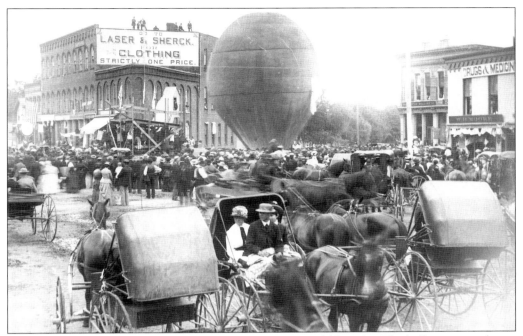

In August of 1884, residents gathered to witness this incredible sight. The balloon was as big as the bank building and required a great many volunteers to hold it down. One filled, the balloon ascended and the crowd watched as a professor parachuted to the ground.

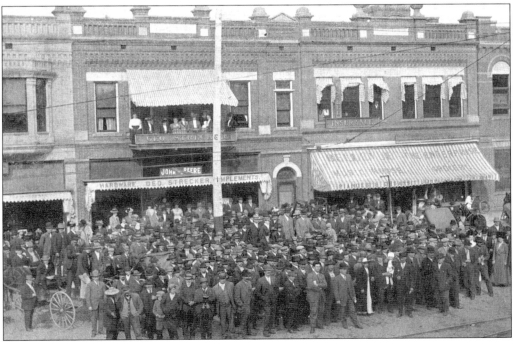

Strecker's Days was a festival held at Geo. Strecker Hardware and Implements. The men attending the event posed for a photo.

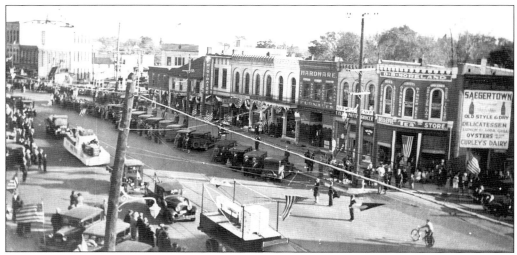

A parade marched through downtown Bellevue in celebration of the centennial in 1953.

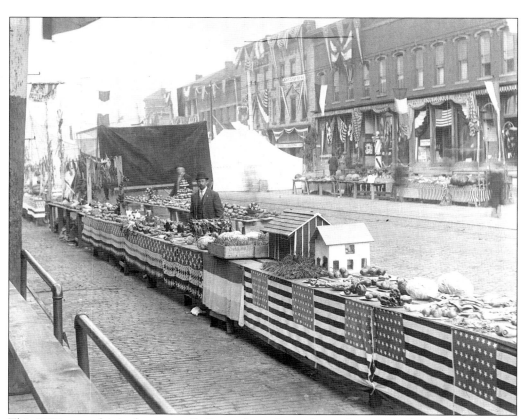

This 1907 street fair in downtown Bellevue shows how vibrant the town and its businesses were.

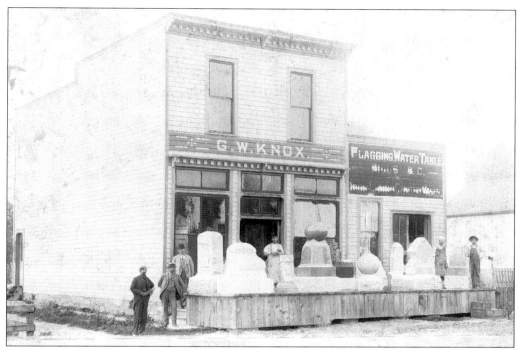

Pictured are the Monument Works on South West Street.

Pictured at Pearl Steam Laundry, from left to right, are: unknown, Mrs. Madison, Mr. Madison, Jane Balder, Tina Sturner, and Grandpa Madison. This building, located at 106 South Sandusky Street, was built in 1896. (Photo taken by Bellevue Photographer Benj. H. Minton.)

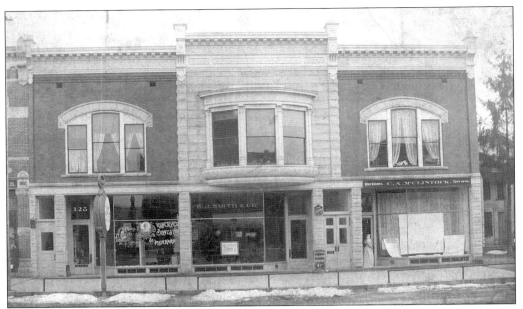

Here is a view of Higgins Block, built in 1896, on the south side of Main Street.

Pictured is the Bellevue Farmers Co-operative in 1913.

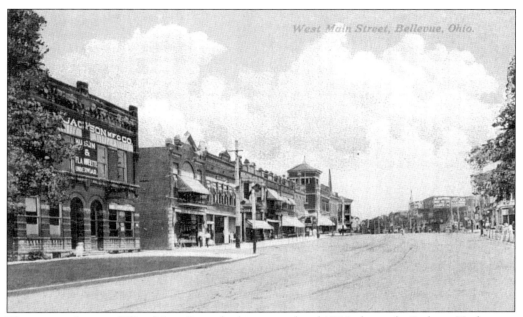

This postcard view of West Main Street looking east, dated 1916, shows the Jackson Underwear building, which burned down and is now part of the Foodtown parking lot.

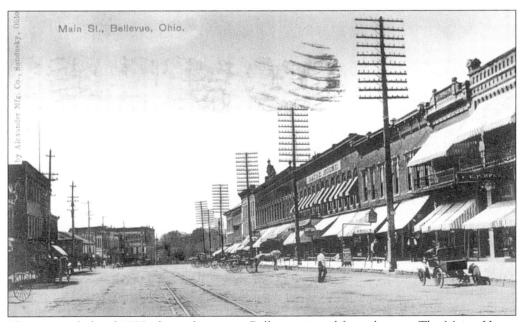

This postcard, dated 1908, shows downtown Bellevue viewed from the east. The Maine House (Hotel) is in center of the picture on the right.

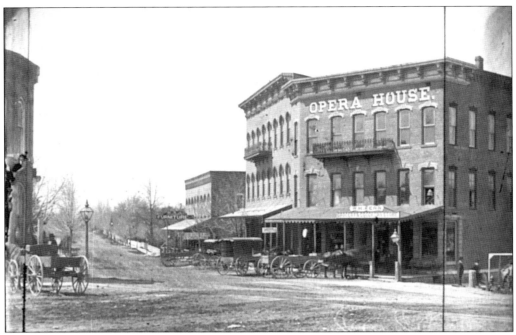

The Opera House, later known as the Allen Hotel, was on the corner of Kilbourne and Main Streets where CVS is now located.

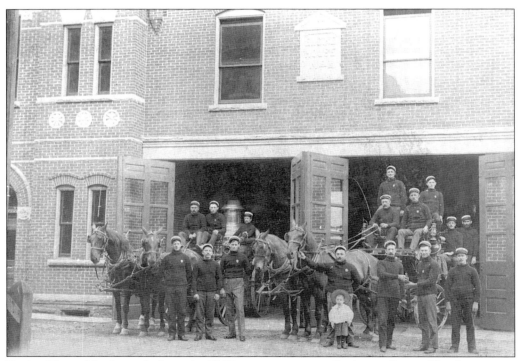

Engine House No. 1 stood where the EMS now operates, on Exchange Street. The firemen are posing with their equipment.

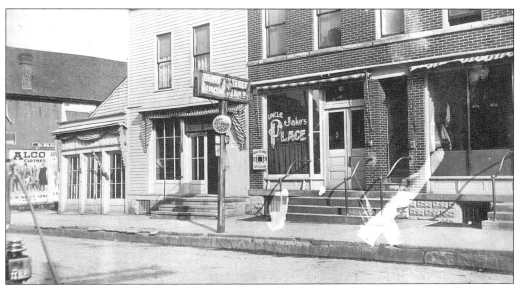

This is the east side of Northwest Street. It shows Jake's Place. The two-story frame building is the Bingle and Hankhammer Meat Market.

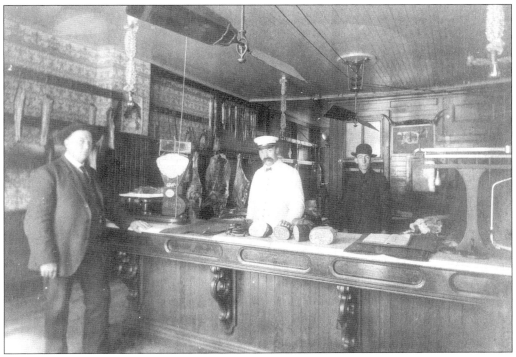

This photo of the W.C. Hankhammer Meat Market was taken before 1900. The customer is Charles Anderson.

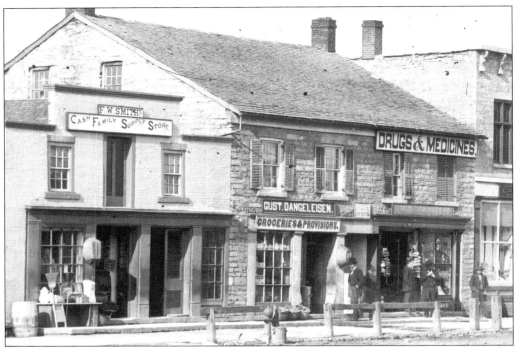

Pictured is the south side of Main Street between the square and Kilbourne Street.

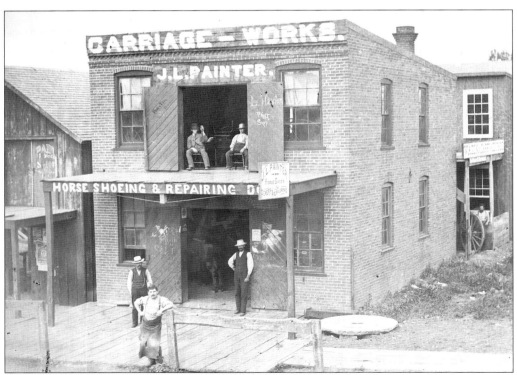

J.L. Painter's Carriage Works, located on Northwest Street is seen in this photo.

Erdrich's Cooperage Works was located on the corner of Sandusky and Center Streets. The man in the center is Mr. Seiler and the man on the right is William Keller.

Pictured are the Stahl Block and the Commercial Hotel at the corner of Sandusky and Main Streets.

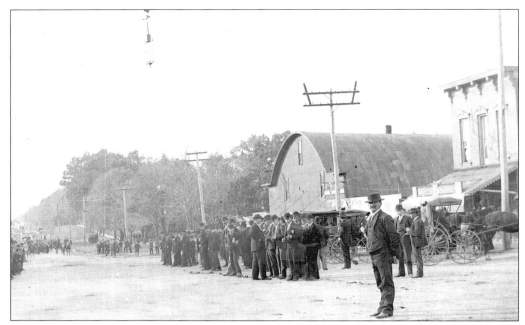

Bellevue residents take advantage of the winter cold at this skating rink on West Main Street, 1892.

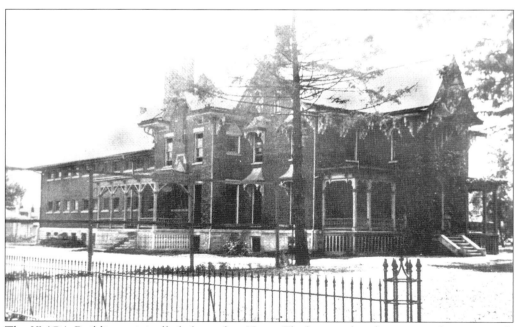

The YMCA Building originally belonged to Henry Flagler, a railroad tycoon and partner with John D. Rockefeller. Flagler was born in Bellevue and later developed much of eastern Florida. This is the present site of the Railroad Museum.

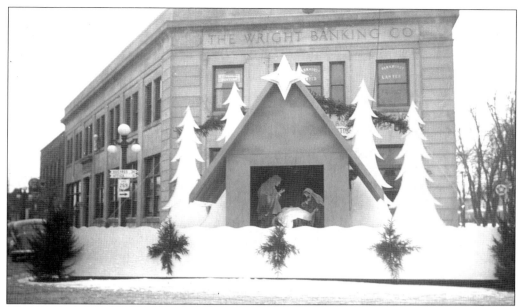

This photo shows the square with the Christmas display at the Wright Banking Company.

Pictured is the Bellevue Hospital on Northwest Street.

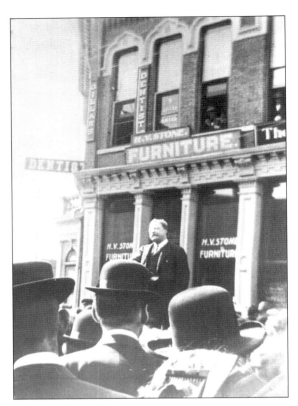

Teddy Roosevelt campaigned twice in Bellevue. He first visited Bellevue in October of 1900 as a candidate for Vice President with William McKinley. As seen here, he spoke from the end car but did not leave the train. Roosevelt again visited Bellevue in May of 1912, while campaigning for president under the Progressive Party.

The dentist, whose office is visible on the second floor of the building, is the father of Axis Sally of World War II fame.

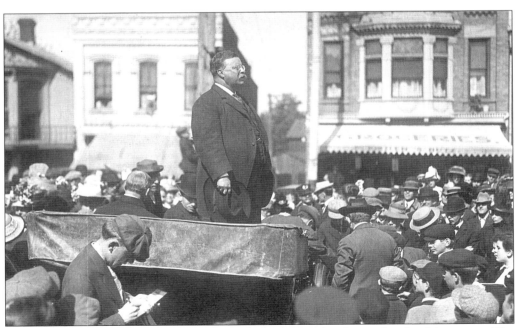

Here is another shot of Teddy Roosevelt. In the background is the south side of the square. The awning that says "groceries" is now Rietz Electric.

This home was located on West Main Street. It was demolished when the Foodtown Store was constructed to make way for a parking area.

Located next to the library for many years, this home was known as the Library House. Dr. Crosby had his office there. It was torn down when the library was enlarged to make way for parking.

This is the Carnegie-Stahl Public Library. It was built with funds from the Andrew Carnegie Foundation and additional money was supplied by Mr. Stahl of Ohio Cultivator Co. for the purchase of books.

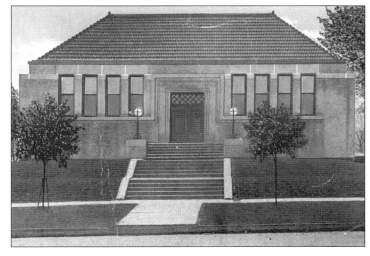

Pictured is the new subway on Main Street in Bellevue.

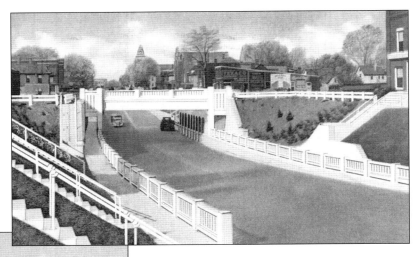

Bellevue's Water Standpipe is a local landmark.

Stand Pipe, Bellevue, Ohio.

Bellevue's City Hall and Fire Department, located on the corner of Main and Exchange Streets, are pictured after burning in a fire on February 2, 1901.

Four

SCHOOLS AND
CHURCHES

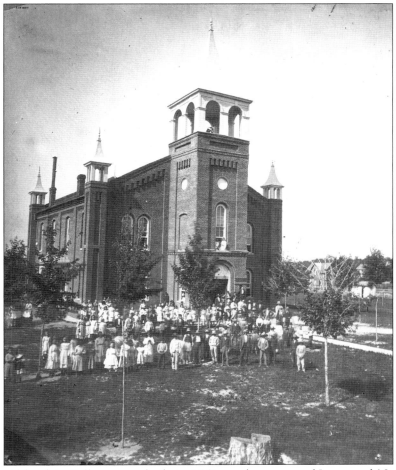

The Union School in Bellevue was built in 1861 on the corner of Lyme and North Streets where the current Junior High stands.

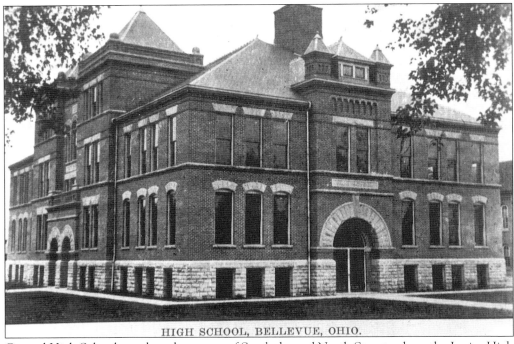

HIGH SCHOOL, BELLEVUE, OHIO.

Central High School stood on the corner of Sandusky and North Streets where the Junior High parking lot is currently located.

Central High School now serves as the Junior High School.

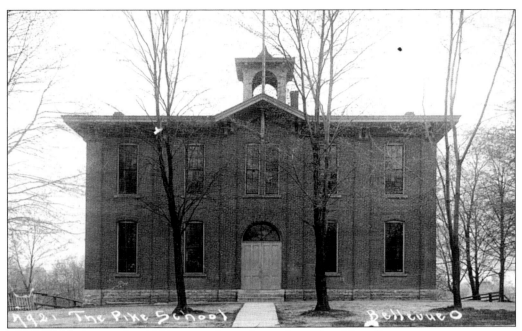

Pike School, seen in this 1921 postcard, was located on West Main Street.

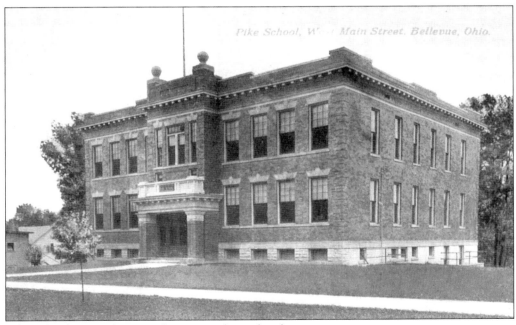

Pike School is seen here on the same sight as the above picture.

St. Mary's School, now known as Immaculate Conception School, operated by the Catholic Church, was located on the corner of East Main and Broad Streets.

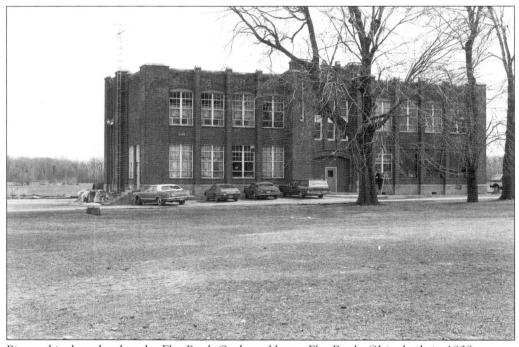

Pictured is the school at the Flat Rock Orphans Home, Flat Rock, Ohio, built in 1929.

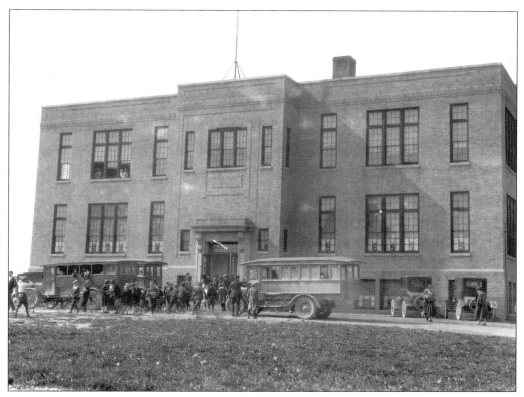

Thompson School, located in Fireside, is seen with buses ready to take the students home in this 1925 photo.

Flat Rock School stood on the corner of County Road 29 and County Road 32.

First Methodist Church, located on the corner of Sandusky and Main Streets, is shown with the original steeple. The church was erected in 1866 and demolished in 1958.

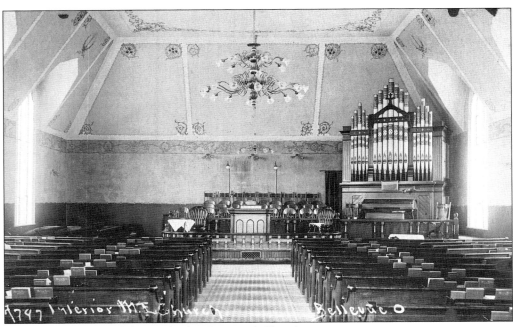

Here is the interior of the Methodist Episcopal Church.

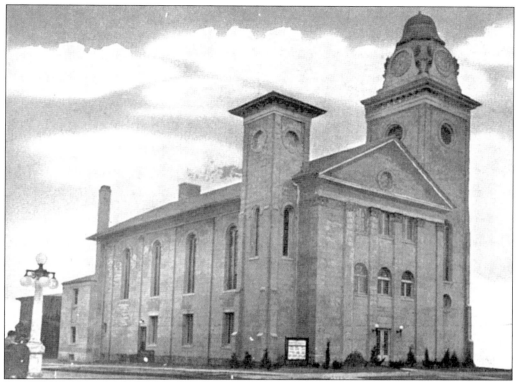

First Methodist Episcopal Church is seen with the replacement steeple, known locally as the corn cob steeple.

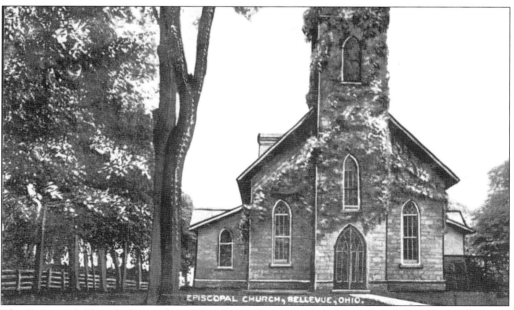

The Episcopal Church, located on West Main Street, is the oldest church building still in use in Bellevue.

The first building for the Lutheran Church in Bellevue was located on Center Street, 1865-1895.

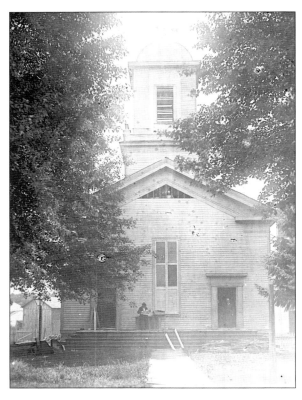

Pictured is the Congregational Church, 1887.

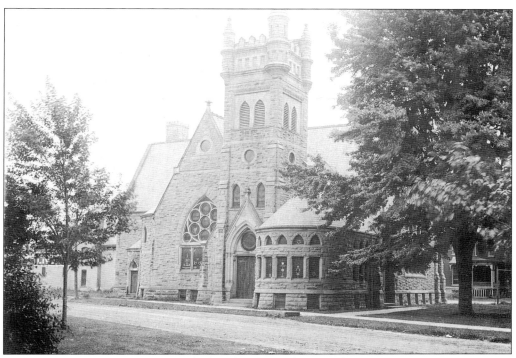

Harkness Memorial Congregational Church is located on Southwest Street.

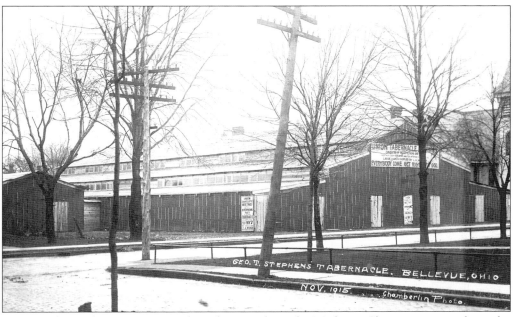

Union Tabernacle was constructed on the site where the Medicine Shoppe now stands, at the corner of Lyme and North Streets. The Evangelist George T. Stephens conducted there in November of 1915.

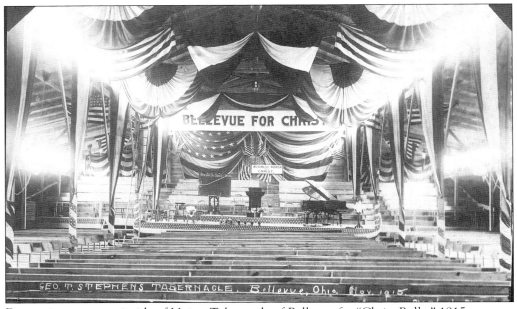

Decorations were set inside of Union Tabernacle of Bellevue for "Christ Rally," 1915.

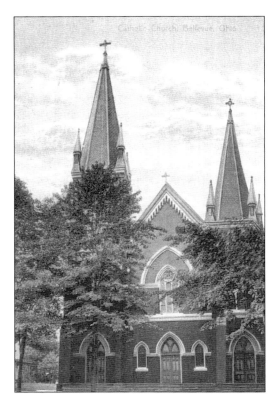

The Catholic Church stands on the corner of Center and Broad Streets.

Five
FLAT ROCK,
EBENEZER ORPHANS HOME,
SENECA CAVERNS

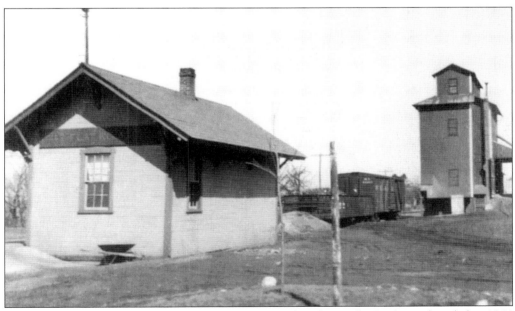

The depot and grain elevator at Flat Rock are seen in this photo. Flat Rock was founded in 1841 by a group of Evangelical families from Mifflin, Pennsylvania.

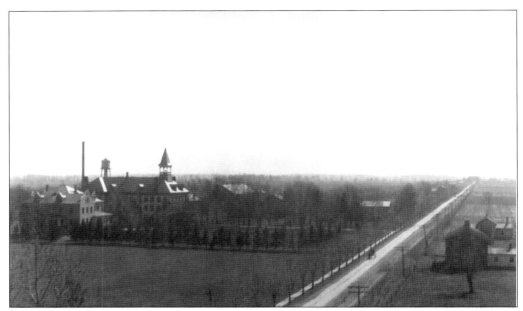

This photo was taken from the Ebenezer Church Tower in 1925. To the south you can see the campus of the Orphan's Home on the left and the Wonder home on the Right.

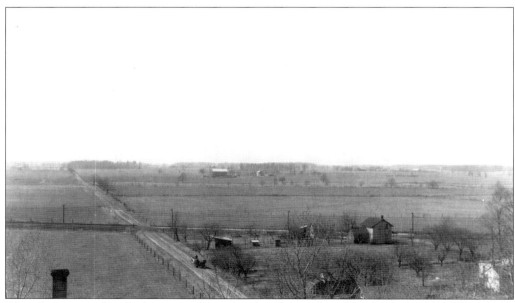

This photo was taken looking west from the church steeple in Flat Rock in 1925. This area is now all part of the large quarry west of the train tracks.

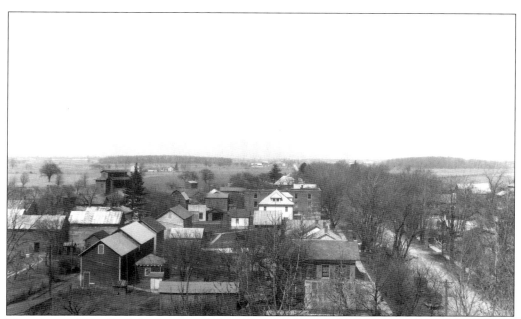

This photo of Flat Rock looking north from the church steeple was taken in 1925.

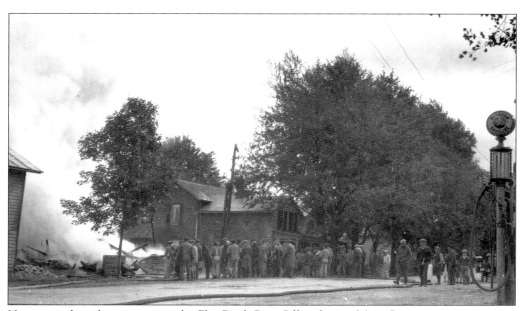

Here, crowds gather to witness the Flat Rock Post Office fire on Main Street.

This old stone building was originally a one-room school, was later used as a car repair shop, and is now used for storage.

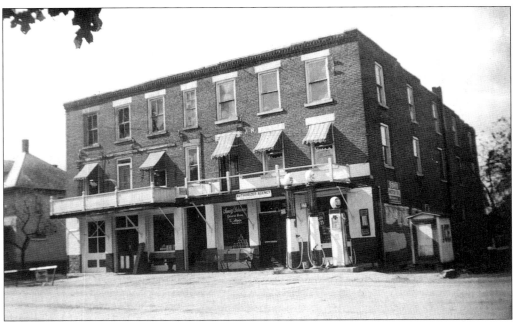

The store block in Flat Rock operated for years as Swartz and Solander. You could buy just about anything you needed there for your food or auto needs.

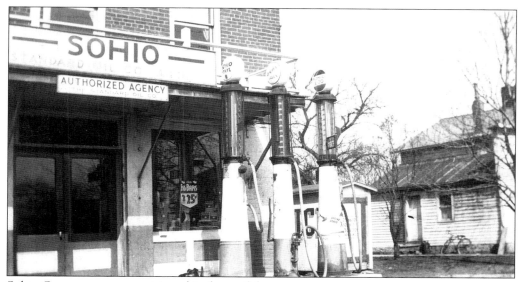

Sohio Gas pumps were positioned in front of the store.

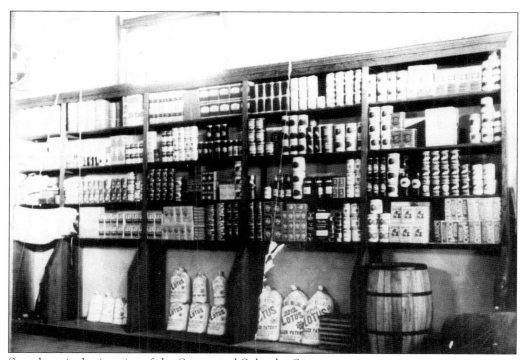

Seen here is the interior of the Swartz and Solander Store.

This old stone Harpster House was built in 1844 on Route 178, near the caverns. This area is now part of the quarry.

This old stone Evangelical Church stood near the caverns, just south of Flat Rock on Thompson Township Road 178. It was built in 1841 and was used until the church was built in Flat Rock in 1871.

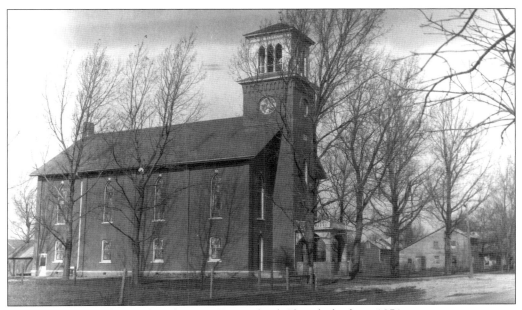

Pictured above is Flat Rock's Ebenezer Evangelical Church, built in 1871.

The Daniel Wonder home, built in 1836, is now part of the Bishop John Seybert/Flat Rock Heritage Landmark, 1925.

This photo of the Ebenezer Orphans Home shows boys with hot water helping to steam the wallpaper off the church while it was being renovated.

The Ebenezer Orphans Home of the Evangelical Association opened in Tiffin, Ohio, in 1866 and relocated to Flat Rock in 1868. The large barn was destroyed by fire in 1966, and the main building was torn down following the 1979 blizzard.

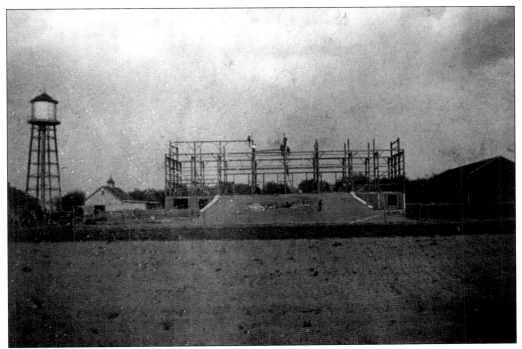

This large barn at the Orphan Home is pictured above under construction.

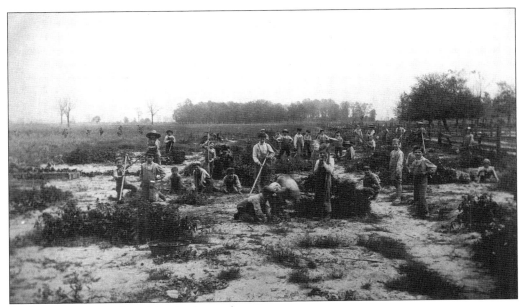

Orphans are pictured working in the garden.

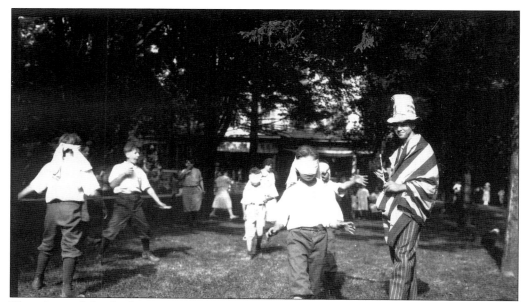

This photo of the Orphans Home captures a Fourth of July celebration.

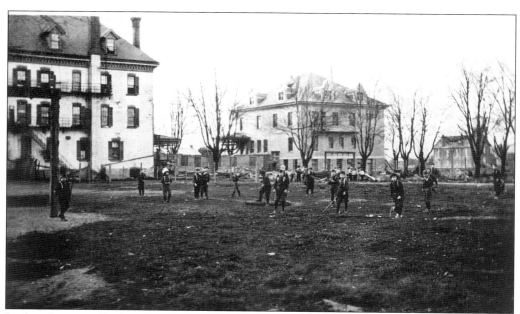

In this photo, an Orphans Home baseball game is in progress. The buildings in the background are the Main Building (left), Girls Dorm (center), and the Church (far right).

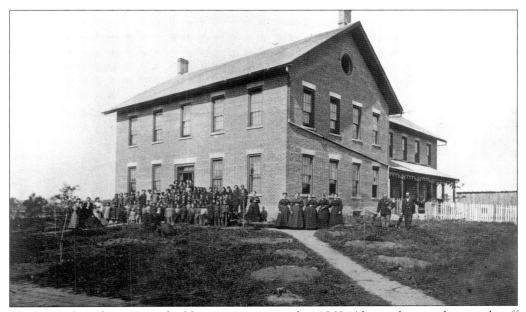

The original Orphans Home building was constructed in 1868. Above, these orphans and staff are posing for a photo.

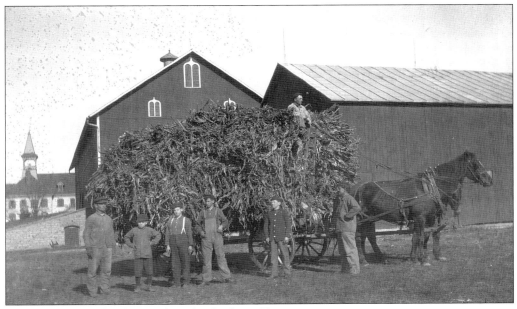

This farm crew is hard at work at the Orphans Home.

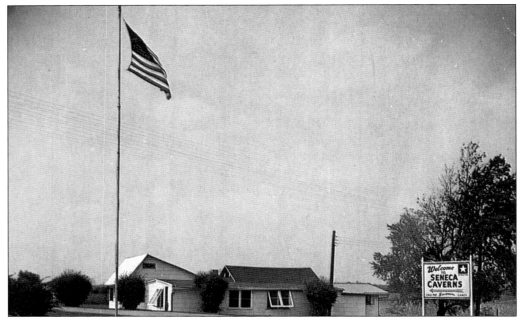

The Seneca Caverns main entrance is pictured here in the 1960s.

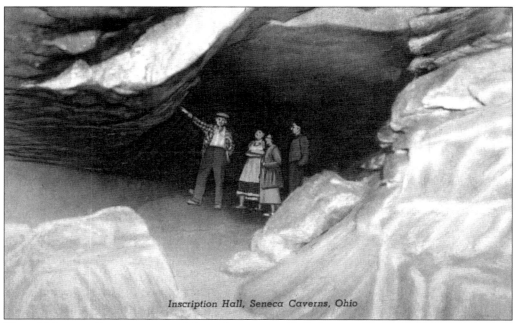

Inscription Hall, Seneca Caverns, Ohio

This old Seneca Caverns postcard shows Inscription Hall. Seneca Caverns is located just south of Flat Rock on Route 178.

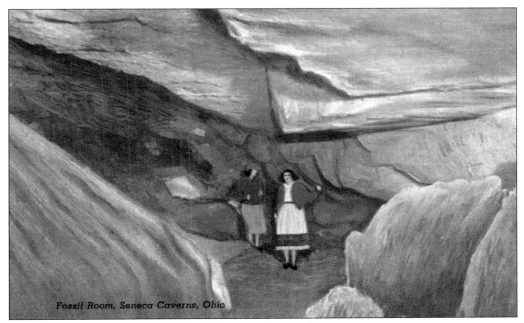

Fossil Room, Seneca Caverns, Ohio

Above, this postcard shows the Fossil Room at Seneca Caverns.

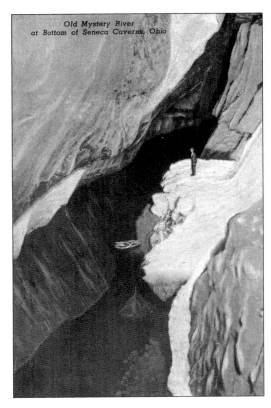

Old Mystery River at Bottom of Seneca Caverns, Ohio

Old Mystery River flows at the bottom of Seneca Caverns—this picture at left is really an exaggeration in relation to the size of the boat and the man.

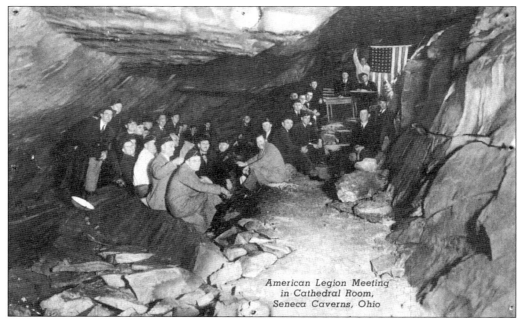

American Legion Meeting
in Cathedral Room,
Seneca Caverns, Ohio

This postcard shows an American Legion meeting held in the Cathedral Room at Seneca Caverns on May 25, 1936.

Seen here is Seneca Caverns' Earthquake Attic.

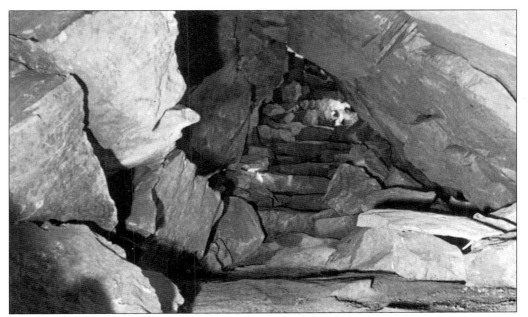

Seen here is what is known as Seneca Caverns' "Attic Door."

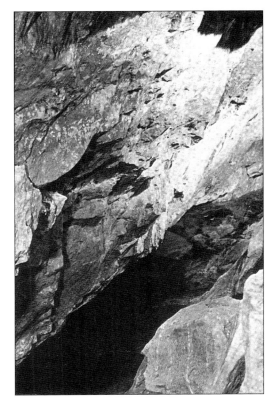

Old Mystery River runs 185-feet below the surface.

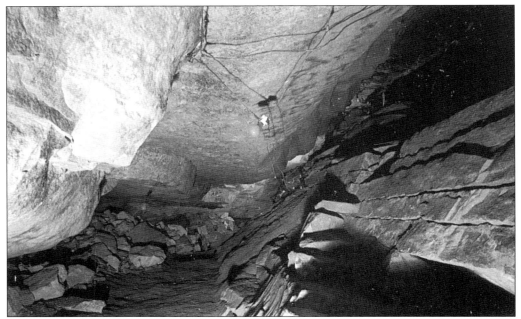

Inscription Hall, in the fourth level of Seneca Caverns, has walls literally covered with names dating back to1872.

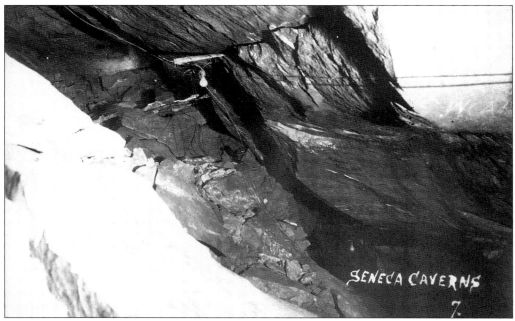

The oldest postcard we have of Seneca Caverns shows the early wiring used for electric light.

Six

BELLEVUE
FLOOD OF 1913

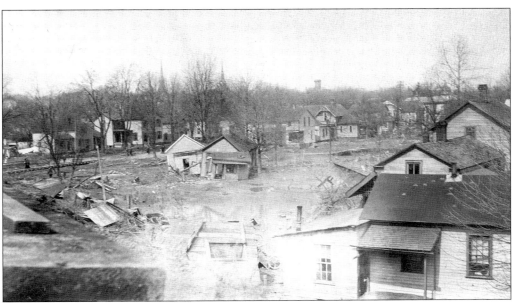

This photo captures the flood damage of the 1913 Bellevue Flood. Bellevue had serious floods in 1913, 1937, and 1969.

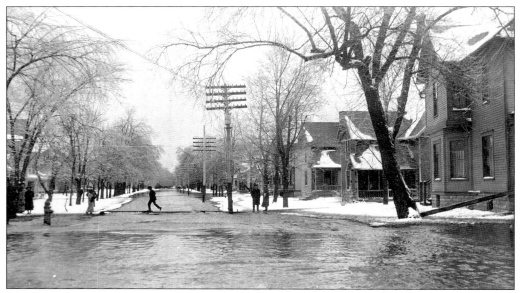
Shown above is High Street during the 1913 flood.

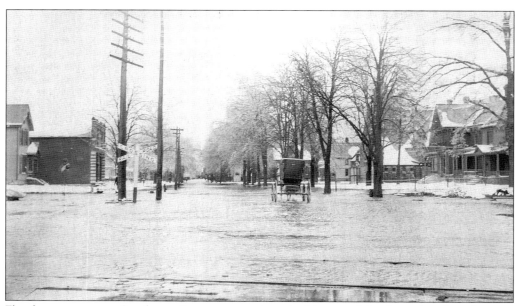
Flood waters rose on Southwest Street, as seen here looking north by the railroad tracks, near the Flagler (YMCA) home and Congregational Church, both to the right of this photo.

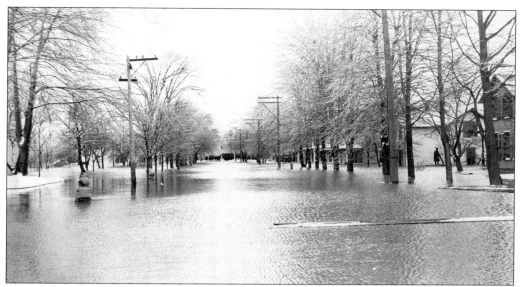

Seen here are more flooded streets in Bellevue, 1913.

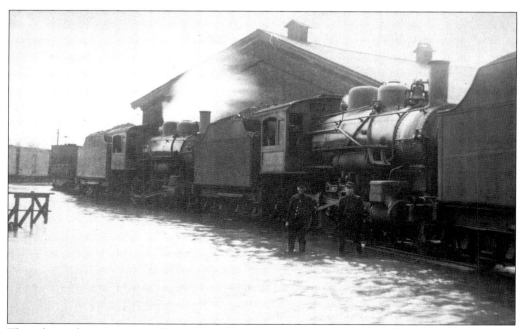

This photo shows trains in front of the Roundhouse during the 1913 flood. Notice the train men standing knee-deep in water.

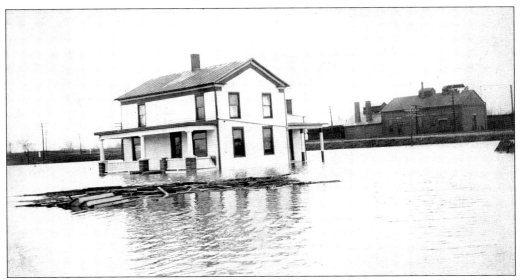

The old gas plant (right) and houses on the west side of Ashford Avenue also suffered from the flood.

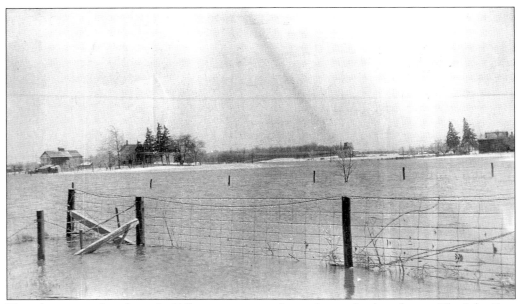

This photo was taken from the Kilbourne train tracks on the south edge of town. The John Fear house on Flatrock Road can be seen—it is now the Schoen home (2002).

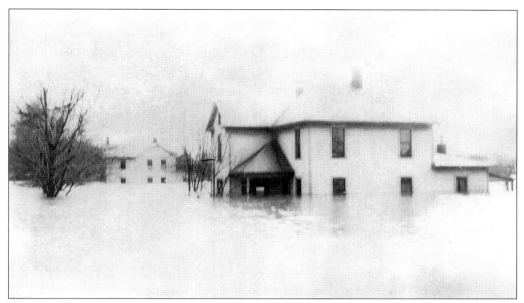

This home on Heter Street was a victim of the 1913 flood.

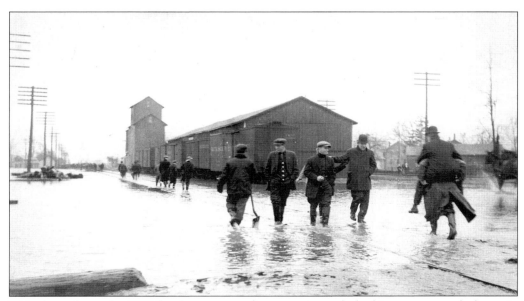

This photo shows the 1913 flood as seen standing on train tracks looking west towards the grain elevator and hay barns, located between York and Kilbourne Streets.

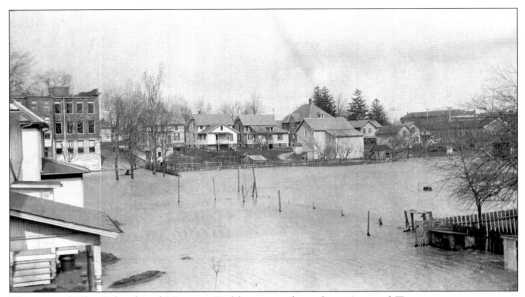

The rear of Pike School and Harmon Field are seen here from Atwood Terrace.

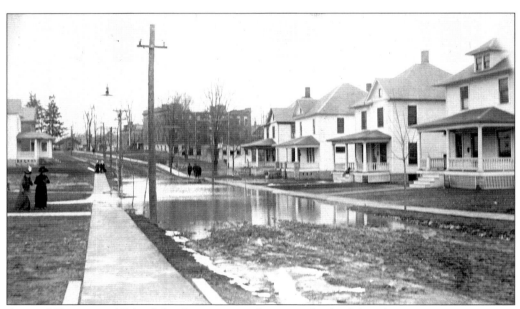

Atwood Terrace and Pike School are seen in the center back of this photo.

Seven

BELLEVUE AND THE SURROUNDING AREA

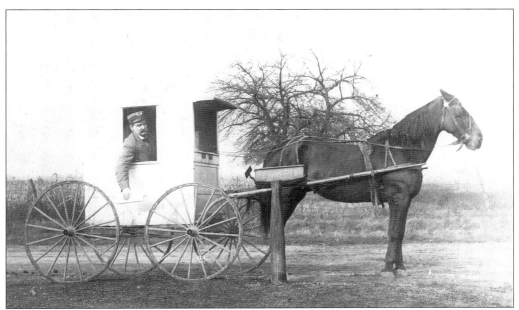

Rural Free Mail Delivery is otherwise known as RFD. This picture was taken in York Township in front of the Kaufman Home on US 20.

The Burgner Family Home, built in 1848 and torn down in the 1980s, was located on Township Road 81 in Thompson Township. There was a book written about the Burgner family that goes into great detail on the building of this house. This was an extremely unusual type of architecture.

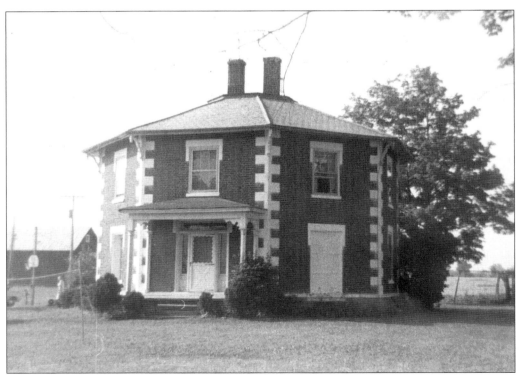

Here is the unique octagon house on Dogtown Road in Sherman Township.

This photo of the Woodward/Dillon home on Young Road in Lyme Township was taken by the author in the 1970s. The two-story section is a fine Greek revival and the back portion is a stone cabin. This beautifully maintained house is a showplace.

This photo of people gathering corn shocks is from the Clara Potter collection.

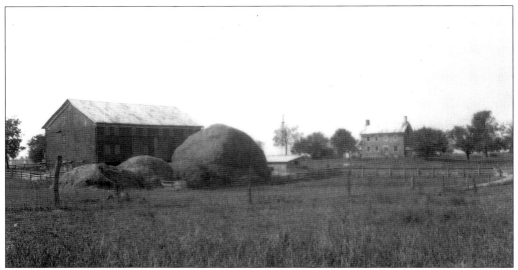

Pictured is the Weiker Homestead in Thompson Township near Flat Rock, 1925. The land is now part of the Hanson Stone Quarry.

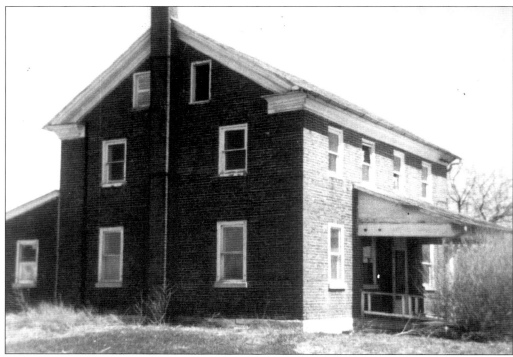

This photo of the Weiker Home was taken in the 1970s. This house was built in 1838 and was torn down in the 1980s.

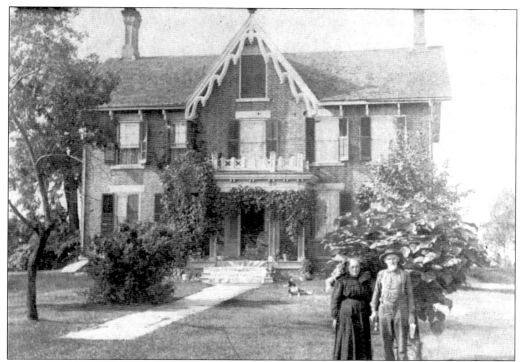

This is a photo of the Tea/Kaufman Homestead still standing in York Township. Built in around 1850 as a tavern on the Maumee Western Reserve Turnpike (US 20), the house has three stories. The second story has a ball room and sleeping rooms, the first floor had a formal parlor, bar room, dinning area, and kitchen.

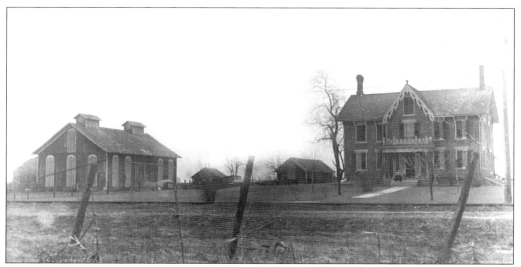

This is another photo of the Kaufman Homestead showing the barn. The barn is a bigger twin to the Biebricher Barn now located at Historic Lyme Village. The Kaufman Barn was originally painted red with white trim and blue louvers in the windows.

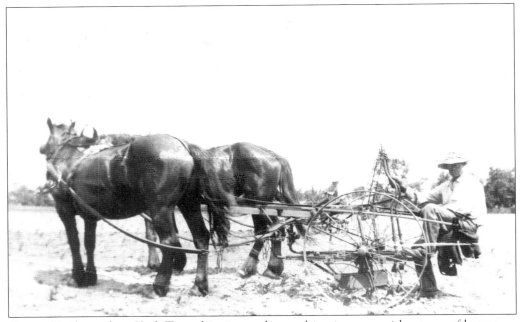

George Kaufman, from York Township, is seen here cultivating corn with a team of horses.

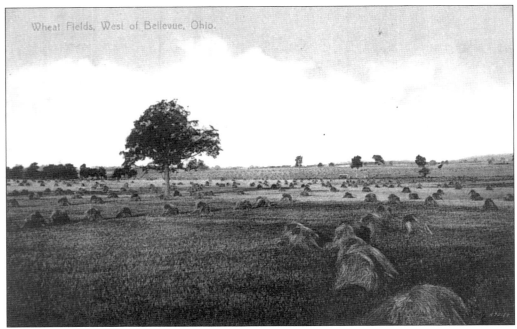

Wheat Fields, West of Bellevue, Ohio.

This 1915 postcard view shows wheat fields west of Bellevue.

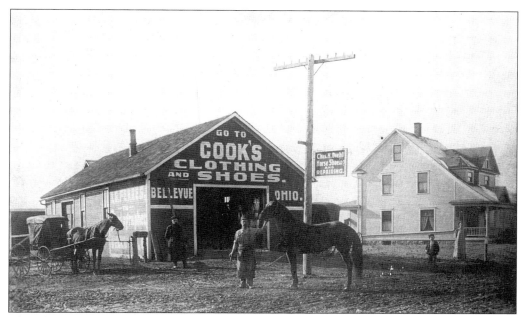

The Chas. Biehl Horse Shoeing Building is shown here in the first decade of the 20th century. Notice the interesting sign on the building for Cook's Clothing and Shoes. This image is from a postcard that was mailed from Clyde, Ohio, to Norwalk, Ohio, in 1907.

Mrs. John Collins is posing on her front porch in 1911, somewhere near Bellevue.

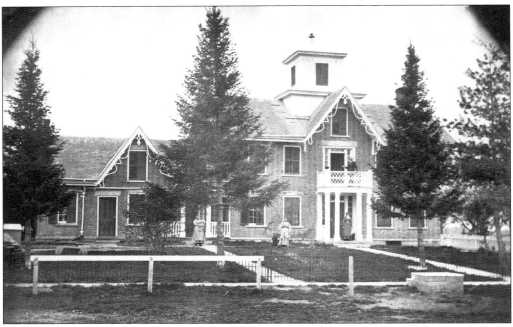

The Barny Kline Homestead is pictured near Kline's Corners (County Road 302 and Route 20 and County Road 177).

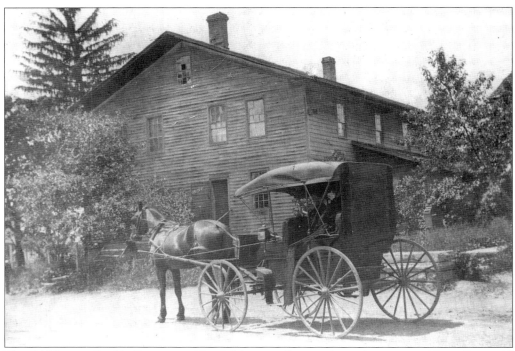

The Old Inn at Cook's Corners, or North Monroeville, stands on the corner of State Route 99 and State Route 113.

The Beckstein Home is on US 20 in Lyme Township. Ernest Beckstein is pictured here with his two daughters.

Posing in front of the White Family Home, from left to right, are Susan (Stower) White, Dorothy White, (?) White, William White, and Fanny White.

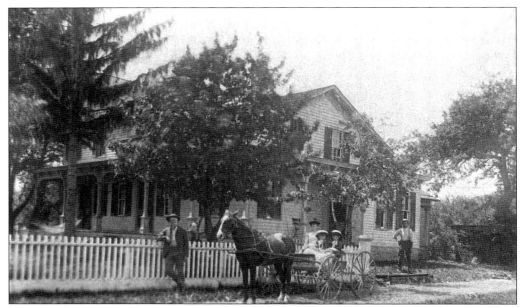

This is a photo of the Melvin Wood Farm located east of Bellevue on State Route 113. Melvin Wood is leaning on the fence; Carrie Wood Wright and daughters Helen and Bessie are in the carriage.

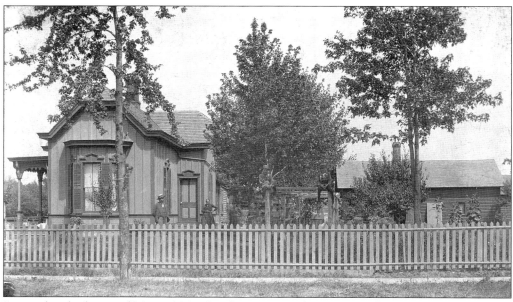

Pictured is the home of Mr. and Mrs. Jacobs on Howard Street in Bellevue.

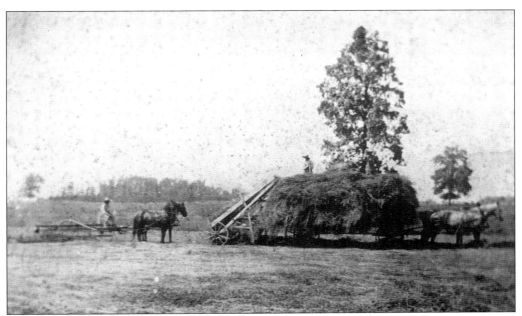

These folks are making hay on the Moyer Farm on County Road 308, just south of Bellevue.

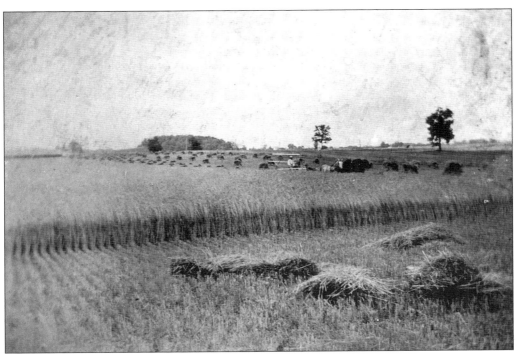

Harvesting wheat is an important job on the Moyer Farm.

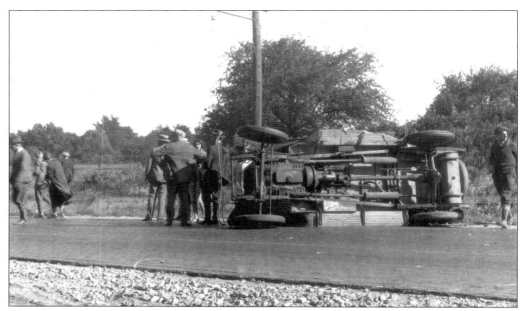

This photo shows an auto wreck in York Township on US 20, west of Bellevue. It seems a bug flew into the eye and temporarily impaired the vision of a driver from Ithaca, New York. Dr. S.E. Simmons of Norwalk owned the car, a brand new Willys-St. Clair sedan. The New York driver ended up in the ditch.

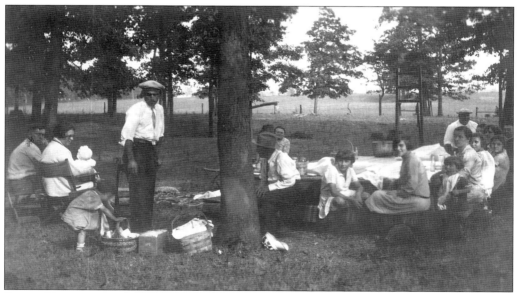

Pictured here is a family picnic being held in the Bert Nearhood Woods near Flat Rock.

This photo is of the Heter/Drown Farmstead, located on Flat Rock Road between Bellevue and Flat Rock, after a snowfall. This house is listed along with its accompanying farm buildings on the National Register of Historic Places. The house was built in 1849 and the barn was built in 1854.

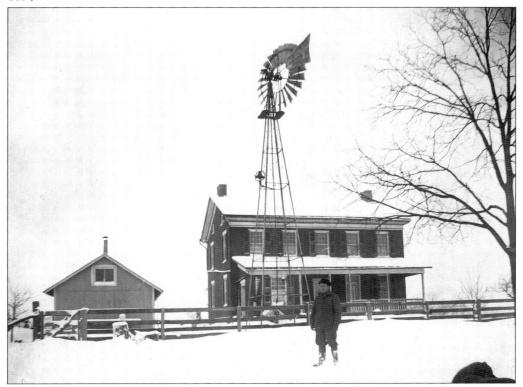

This is the Weiker Homestead on Township Road 81 just south of Thompson Center.

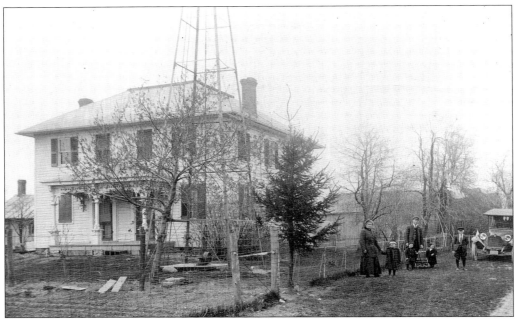

The John Heter Home is located on State Route 18, south of Fireside. This was the home where the Heter cowbell was found, which is mentioned in the Historic Lyme Village section of this book.

This is a rare photo of the Hankhammer family camping at Cedar Point in 1907. The area remains a vacation spot to this day for people in the Bellevue area and is known all over the world.

Eight

LAKE SHORE ELECTRIC AND RAILROADS

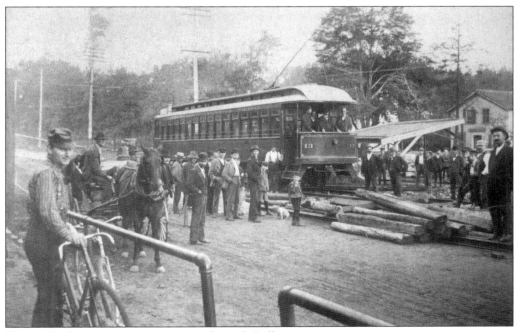

This is the first street car ever to run through Bellevue.

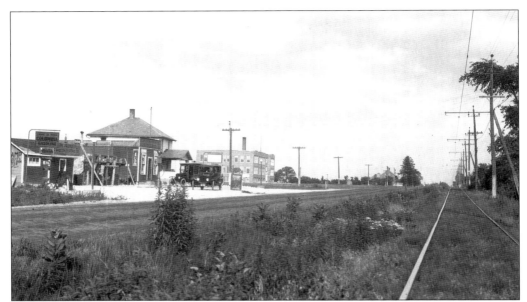

This photo gives us a good view of the street car tracks west of Bellevue. York School is seen in the background. A restaurant, grocery, gas station, and tourist cabins are on the left. The parker home is visible in the center at a distance. Overhead Electric was used to operate the streetcars. Note that, at the time, US 20 was brick.

Here is Musser Substation as it looked in the 1970s.

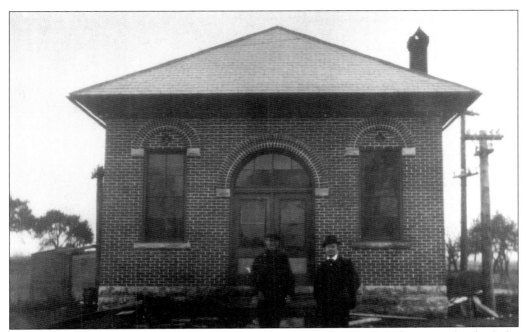

This early-1900s photo shows the Musser Substation, which provided electricity for the Lake Shore Electric (LSE).

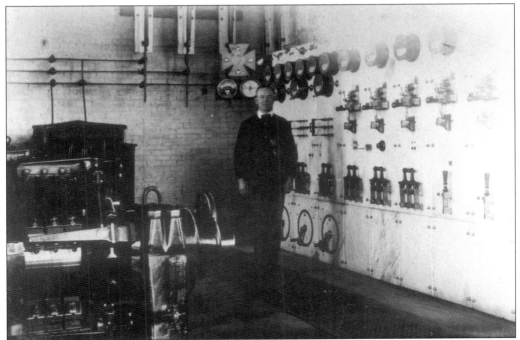

An interior view of the Musser Substation shows the equipment that was housed there in 1907. The man in the picture is LSE employee Frank McHugh.

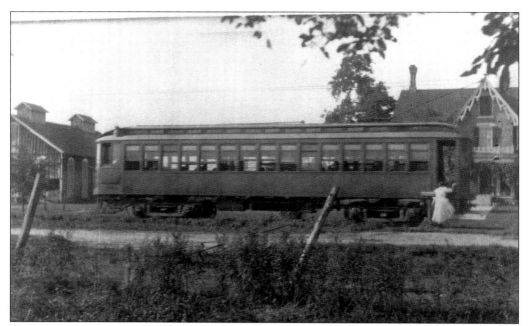

This LSE interurban car is picking up a passenger (Nell Kaufman) in front of the Kaufman home west of Bellevue.

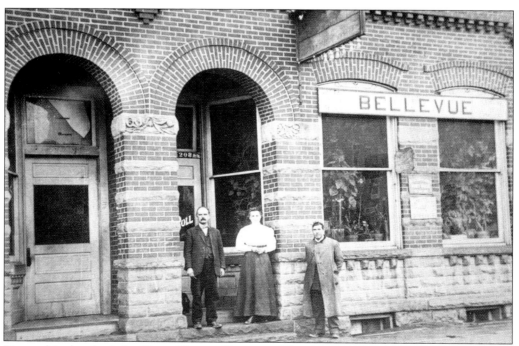

Pictured is the the Lake Shore Electric Depot on West Main Street in Bellevue—street cars could travel down the alley to a loading dock for freight. It is now located at the southeast corner of the Foodtown parking lot. Above, station agents Frank and Carrie Smith are standing in the doorway.

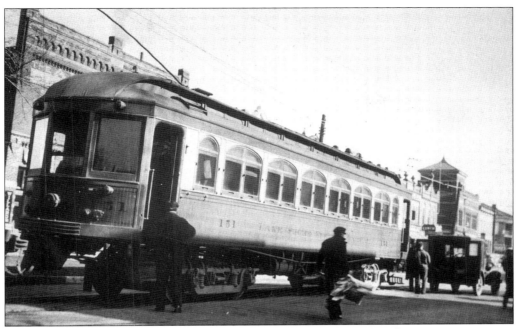

An Interurban car is loading in front of Bellevue station on West Main Street.

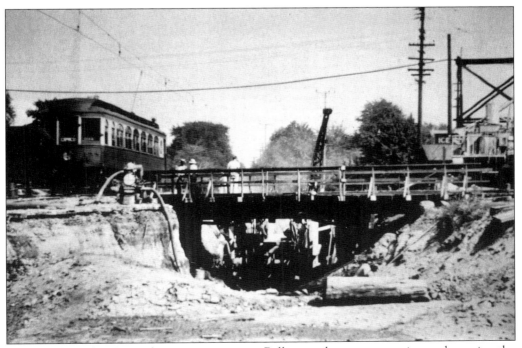

This is a shot of an Interurban car passing over Bellevue subway construction and crossing the railroad grade on East Main Street.

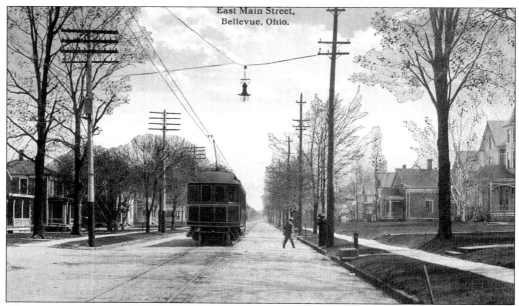

This postcard view looking east, shows the streetcar traveling down East Main Street, 1913.

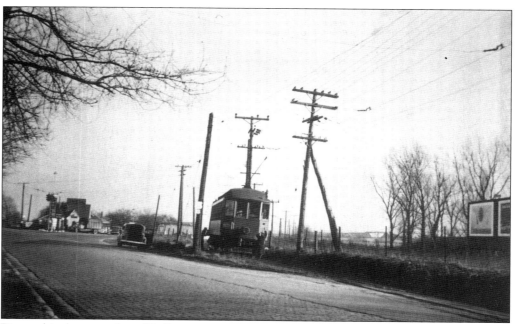

Pictured is the east edge of Bellevue.

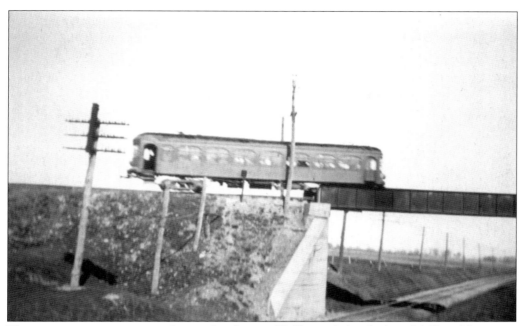

This streetcar is passing over the overhead east of Bellevue, behind where McDonald's is now located. The concrete abutments still stand.

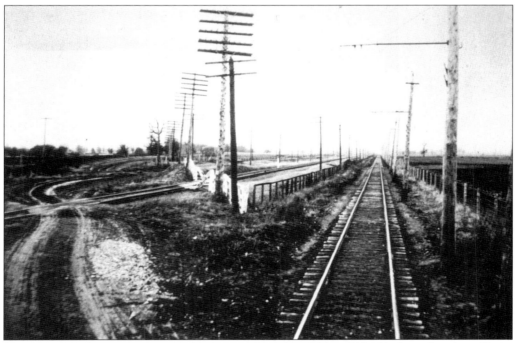

Shown here is the intersection of what is now Bauer Road (then US 20), the railroad, and Lake Shore Electric.

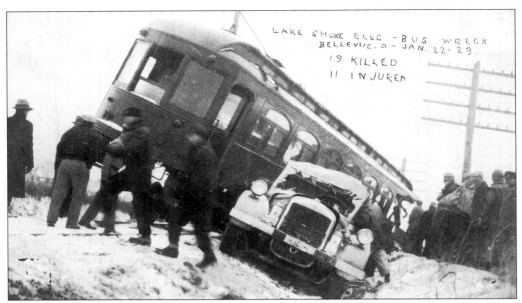

In this Lake Shore Electric bus wreck, at the intersection shown on the previous photo, 19 people were killed and 11 injured.

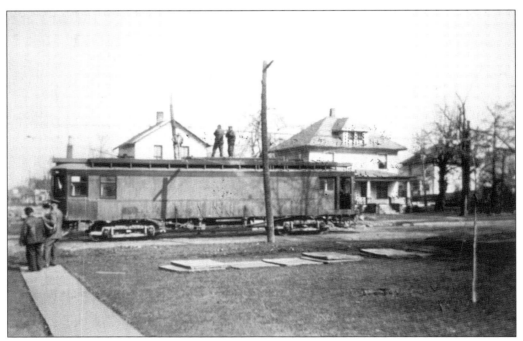

This is a photo of the last streetcar through Bellevue—the end of an era. This photo was taken on East Main, just east of the subway. (Courtesy of the Kingsly photo collection.)

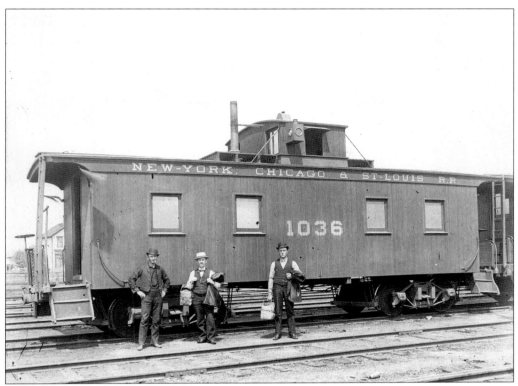

This dapper 1890s-era Nickel Plate Freight Crew is about to depart Bellevue for Conneaut, Ohio. Judging by visible watch chains, being on time was important. The baskets in hand indicated some fine caboose cooking to come.

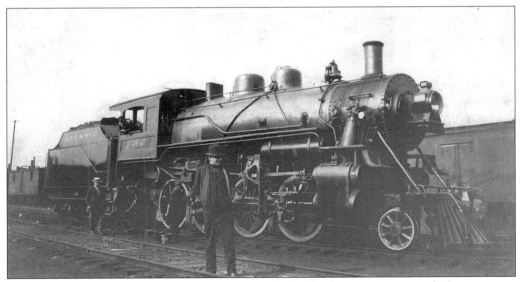

The Conductor and his Engineer pose with their high wheel passenger engine before a run on the Nickel Plate High Speed Line in the early 1900s.

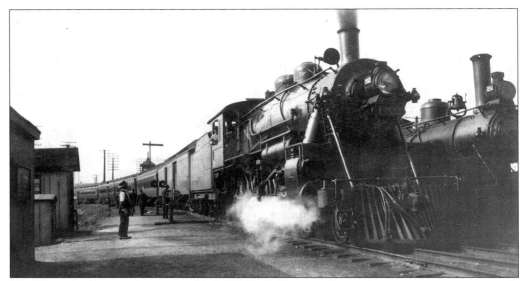

The Engineer has just been given "The High Ball" to get his passenger train out of town. It appears to be an east bound train from the early 1900s, Engine 152. This is a Brooks Locomotive of 1906. It was retired *c*. 1933.

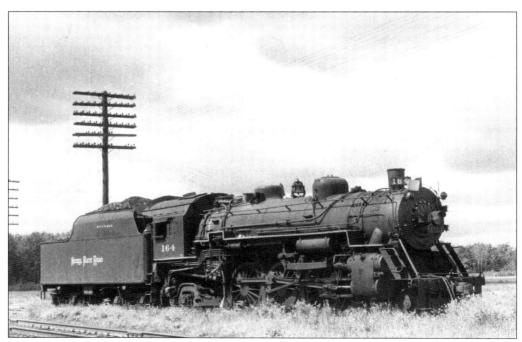

NKP Locomotive 164 is pictured here running its last days out on an extra work train built by Brooks in August of 1923. Wrecked at least twice in the 1920s, it lasted until November of 1952. It was sold for scrap on February 14, 1953.

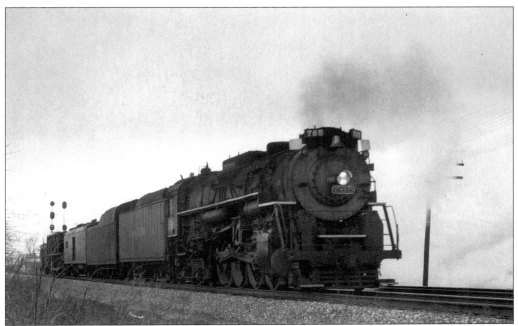

NKP 2-8-4- S-2 Berkshire is pictured above returning to Bellevue in the fall of 1983 after spending the summer in the south pulling excursion trains all over the Norfolk and Western System.

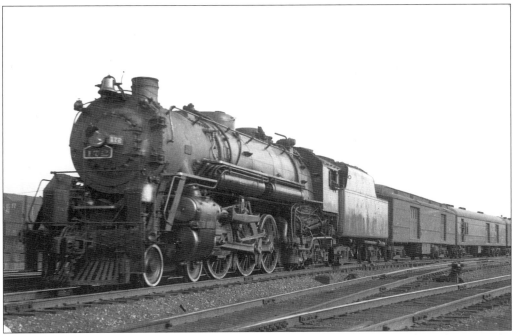

NKP no 172 built by Brooks Locomotive Works in March of 1927 is shown here departing for Bellevue after WWII from 63rd Street Station in Englewood, Illinois. The railroad post office car is second from the Tender.

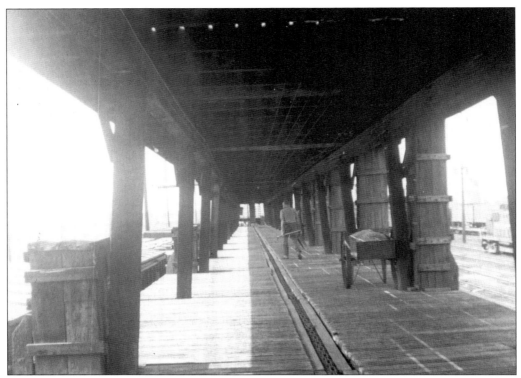

This photo shows the lower deck of the Bellevue car icing platform. This deck was 15-feet above the ground and was used to place 100-pound blocks of ice in the ice bunkers of Refer cars.

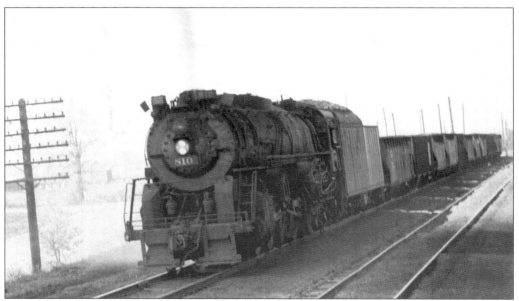

Pictured above is the Ex Wheeling & Lake Erie 6410, now NKP 810 – 2-8-4, making its last run from Cleveland to Bellevue on May 8, 1958. It was sent to Trenton, Michigan for scrap on November 24, 1959.

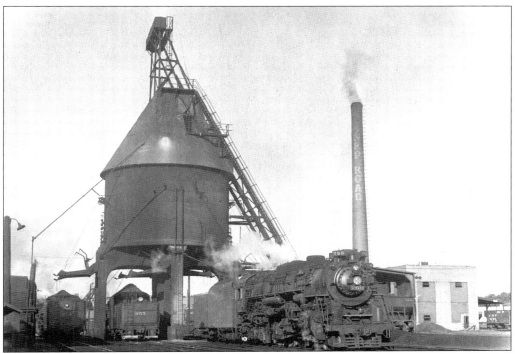

This is a photo of the Bellevue, Ohio coal dock and service pit for steam locomotives. The Roundhouse smoke stack proudly displays the owner's name, c. 1950s.

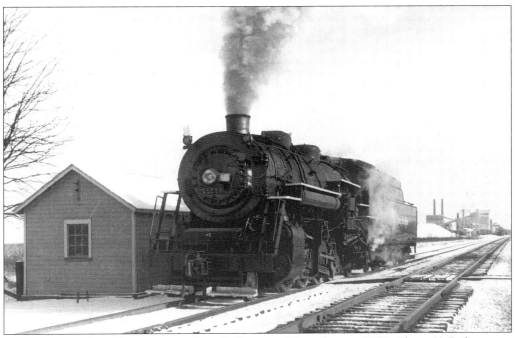

NKP 2-8-2 working the stone run from Bellevue to Nario late in 1957. These H-5 class were some of the last steamers in use out of Bellevue.

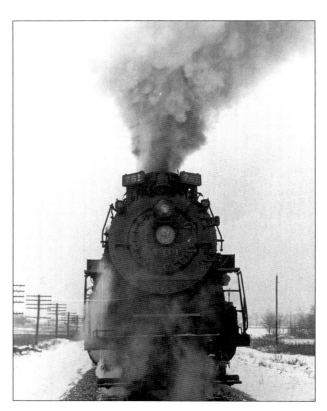

NKP Road 2-8-4 no. 761 is pictured here on one of its final runs during the winter of 1957-58 just east of Bellevue on " The Main Line." It was retired in April of 1958 and sold for scrap in October of 1963

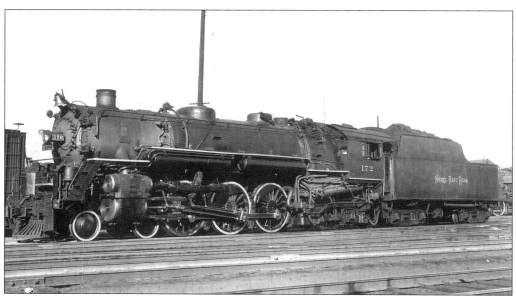

Waiting for a late Nickel Plate passenger train to arrive, Bellevue NKP Hudson passenger locomotive no-172 is coaled up and ready for its run to Fort Wayne, Indiana located 127 miles to the west.

124

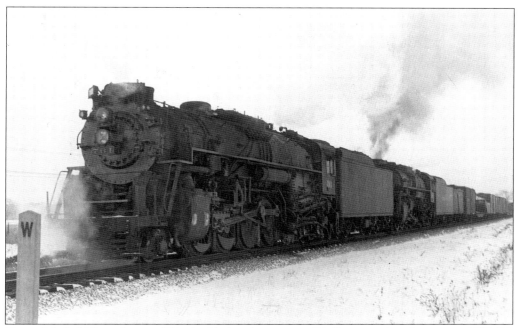

Two of Nickel Plates famous 700s double head west out of Bellevue in their last years, 1955-56. The 2-8-4 held the best runs until the last of the steam era.

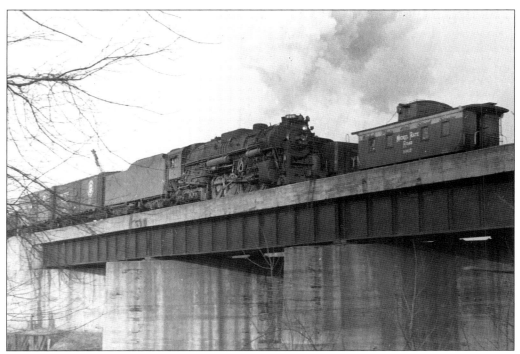

Nickel Plate Road trains are seen here going in both directions over the Sandusky River at Old Fort. The steam locomotive is heading toward Bellevue and the caboose had just left when this photo was taken *c.* 1955.

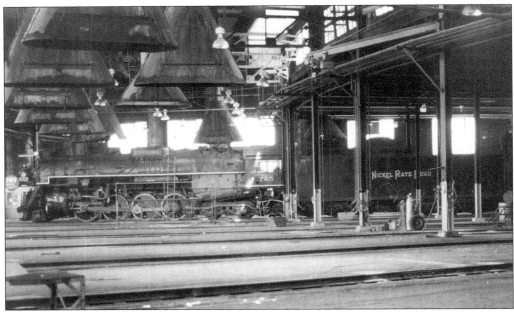

NKP-765 2-8-4 is seen here ready to start the 1984 excursion season. This was the last NKP steam engine to be serviced in Bellevue's Roundhouse built in 1947. The Norfolk Southern had closed and moved to the new engine house at Route 4 by this time.

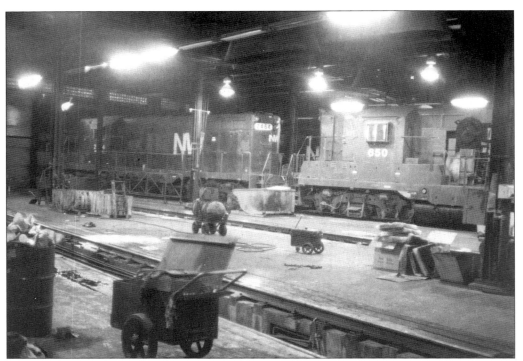

This photo shows the last shift in the Bellevue Roundhouse. An ex-NKP locomotive – 454 (now 2454) and a 6p-9-650 spend their last days stored in the roundhouse.

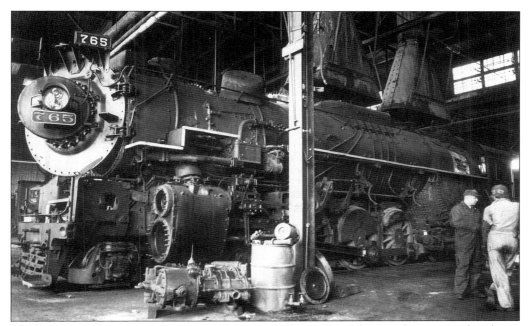

The last steam locomotive was repaired in the Bellevue Roundhouse after it was closed as a regular engine servicing facility. The Fort Wayne Railroad Historical Society crew are pictured here making repairs during the winter of 1984 for a spring excursion trip from Toledo to Bellevue. (A. Glen Brendal photo.)

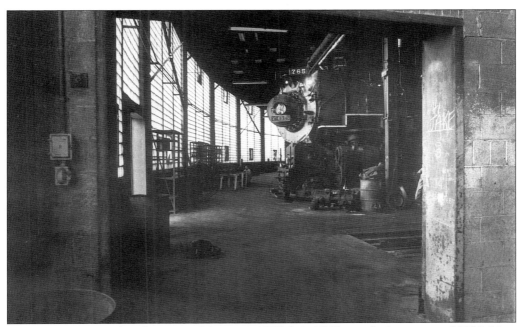

The Fort Wayne Railroad Historical Society's NKP 2-8-4 765 spends the winter of 1983-84 in the Old Bellevue Roundhouse. (Photo by Glen Brendal of the Fort Wayne Group.)

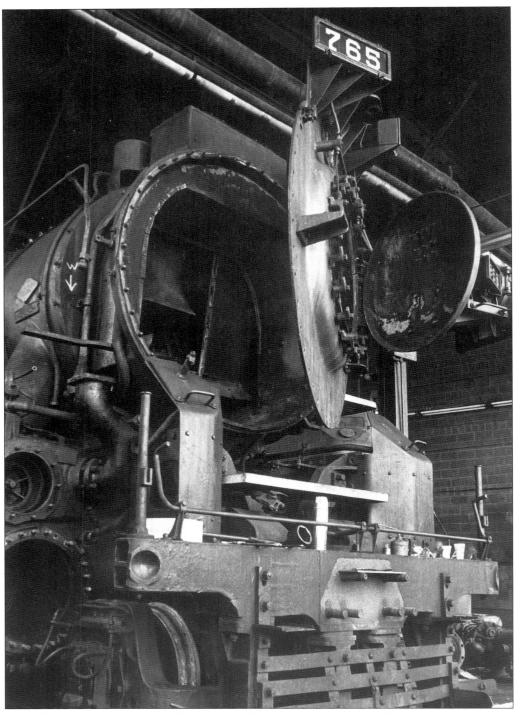

This NKP 2-8-4, built by Lima Locomotive Works in September of 1944 spent the winter of 1983-84 having boiler work done in the Bellevue Roundhouse after it spent the summer of 1983 in excursion service for the Norfolk-Southern Corp. (Photo by Glen Brendal.)